image comics presents

COLORING BOOK

art by
CHARLIE ADLARD

SKYBOUND

For SKYBOUND ENTERTAINMENT

Robert Kirkman - CEO
David Alpert - President
Sean Mackiewicz - Editorial Director
Shawn Kirkham - Director of Business Development
Brian Huntington - Online Editorial Director
June Alian - Publicity Director
Rachel Skidmore - Director of Media Development
Jon Moisan - Editor
Arielle Basich - Assistant Editor
Dan Petersen - Operations Manager
Nick Palmer - Operations Coordinator
Genevieve Jones - Production Coordinator
Andres Juarez - Graphic Designer
Stephan Murillo - Business Development Coordinator

International inquiries: foreign@skybound.com
Licensing inquiries: contact@skybound.com
WWW.SKYBOUND.COM

image

IMAGE COMICS, INC.
Robert Kirkman – Chief Operating Officer
Erik Larsen – Chief Financial Officer
Todd McFarlane – President
Marc Silvestri – Chief Executive Officer
Jim Valentino – Vice-President

Eric Stephenson – Publisher
Corey Murphy – Director of Sales
Jeff Boison – Director of Publishing Planning & Book Trade Sales
Jeremy Sullivan – Director of Digital Sales
Kat Salazar – Director of PR & Marketing
Emily Miller – Director of Operations
Branwyn Bigglestone – Senior Accounts Manager
Sarah Mello – Accounts Manager
Drew Gill – Art Director
Jonathan Chan – Production Manager
Meredith Wallace – Print Manager
Briah Skelly – Publicity Assistant
Sasha Head – Sales & Marketing Production Designer
Randy Okamura – Digital Production Designer
David Brothers – Branding Manager
Ally Power – Content Manager
Addison Duke – Production Artist
Vincent Kukua – Production Artist
Tricia Ramos – Production Artist
Jeff Stang – Direct Market Sales Representative
Emilio Bautista – Digital Sales Associate
Leanna Caunter – Accounting Assistant
Chloe Ramos-Peterson – Administrative Assistant
IMAGECOMICS.COM

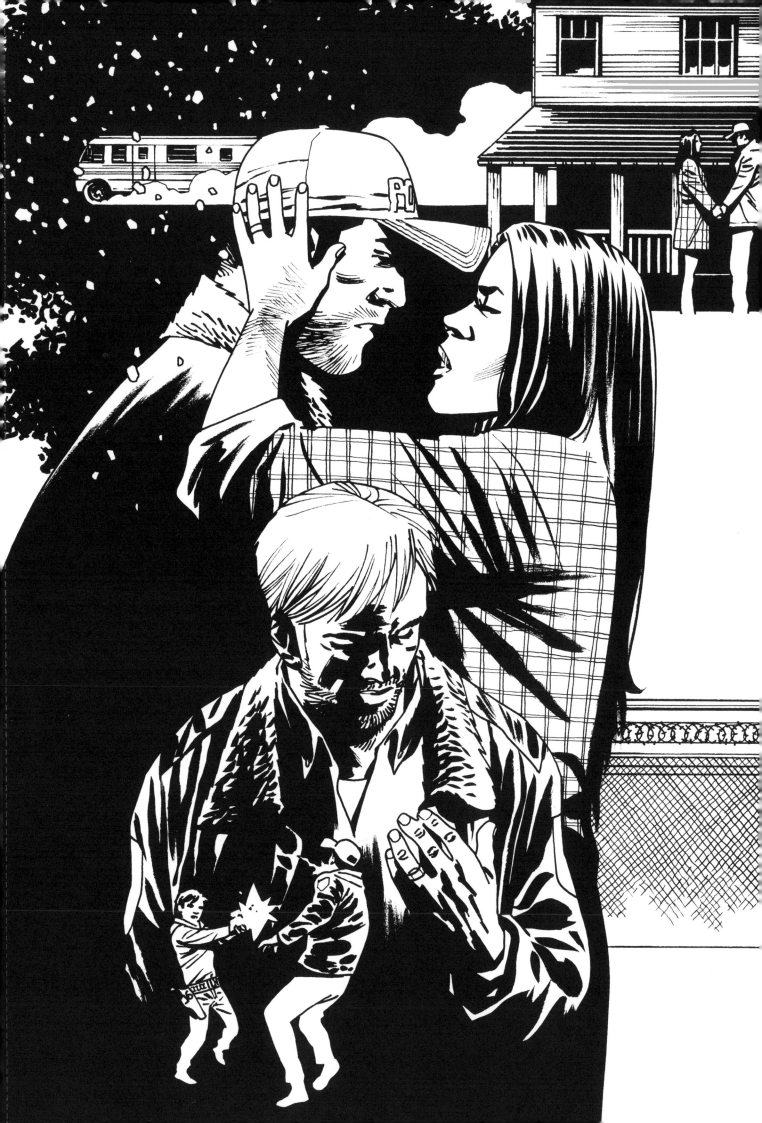

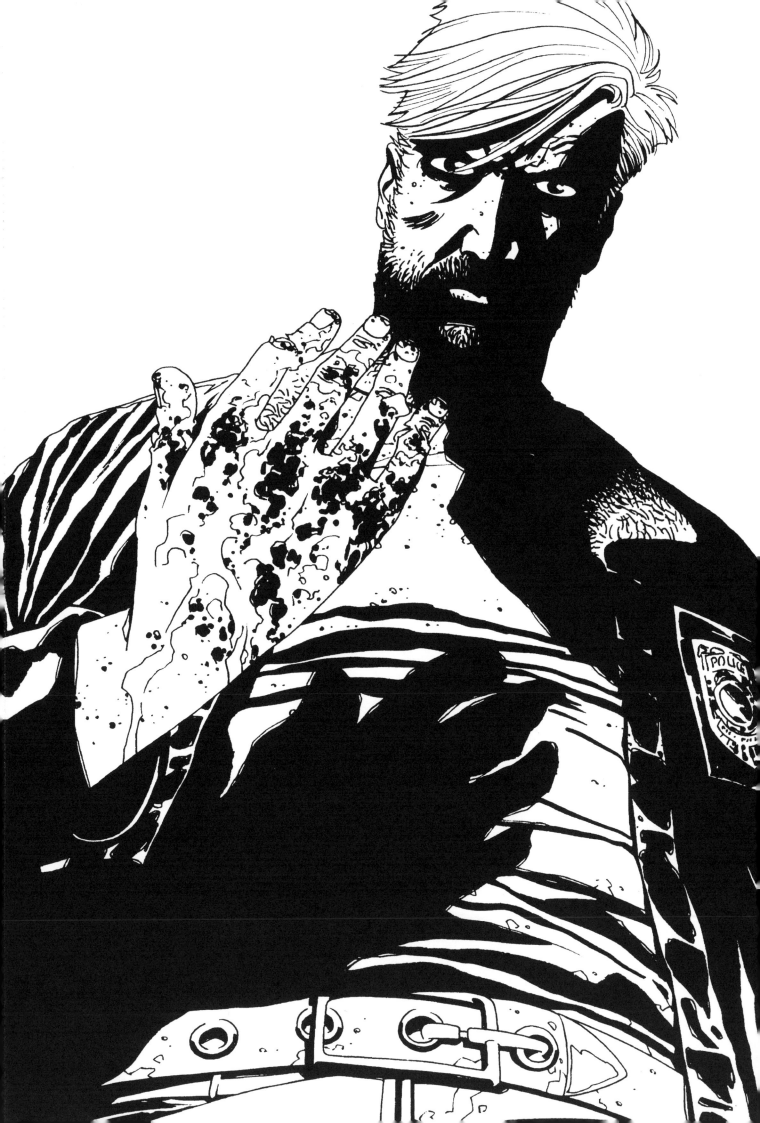

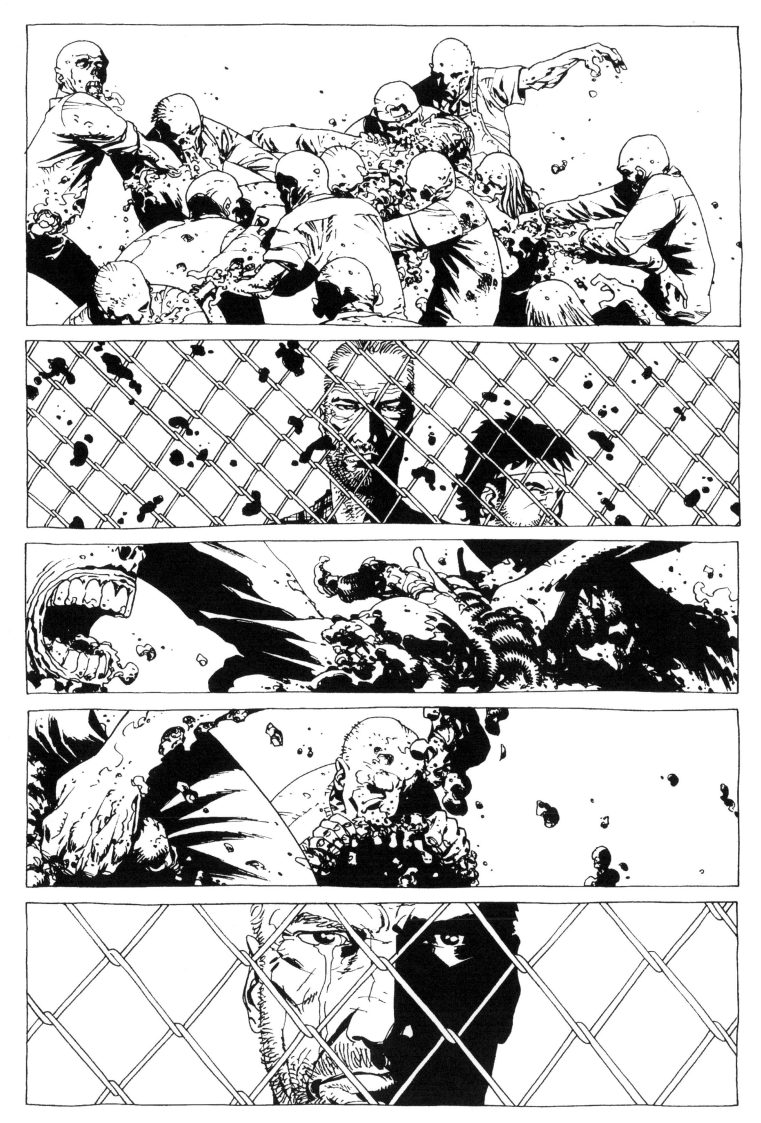

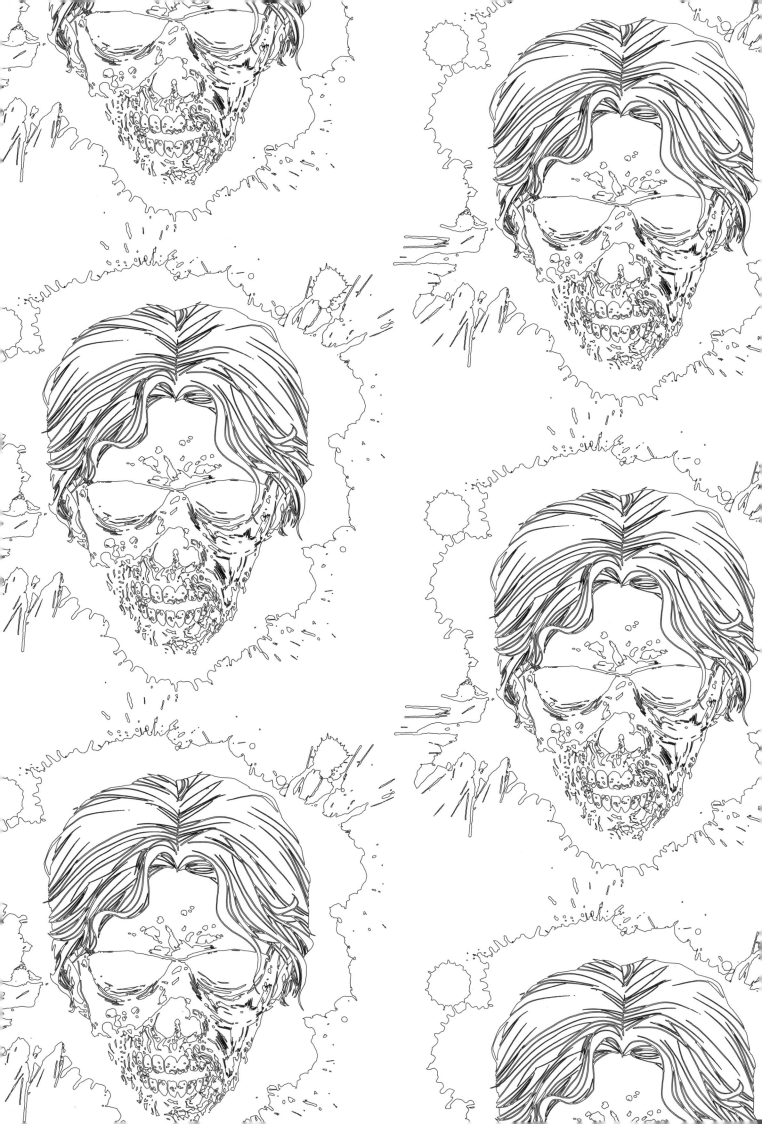

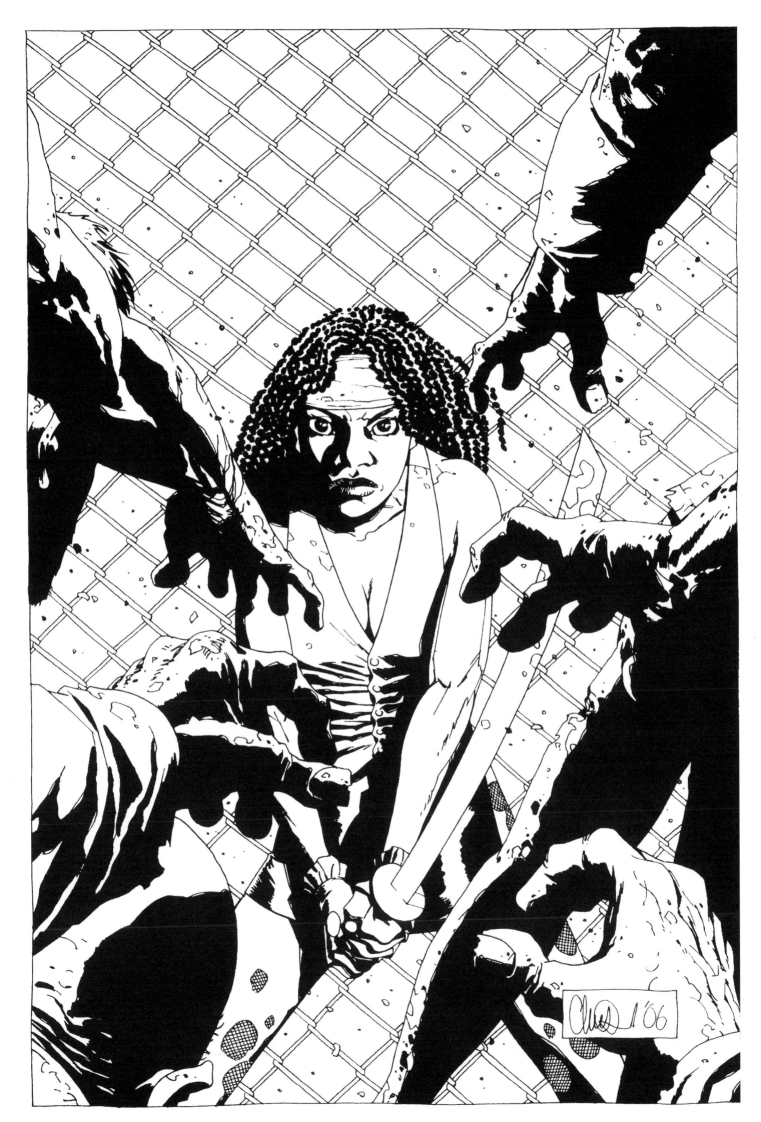

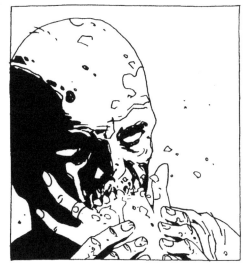
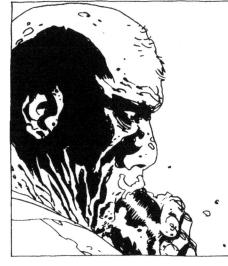
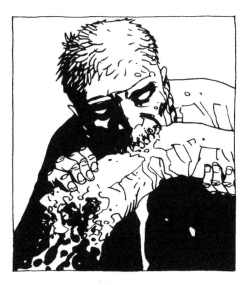
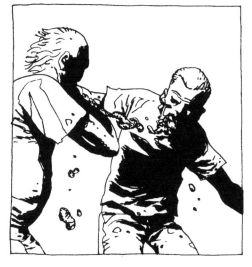
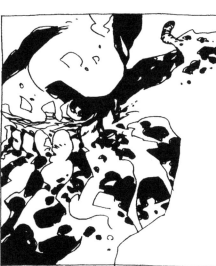
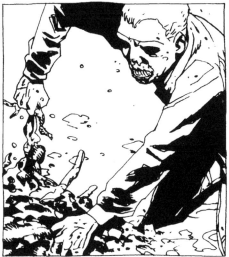
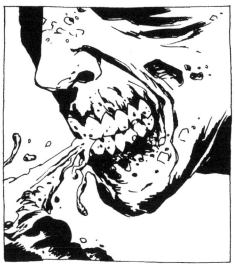
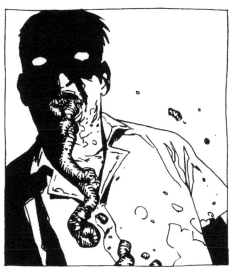
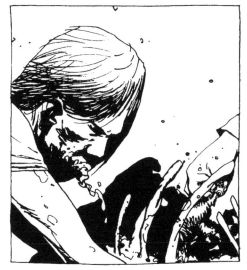
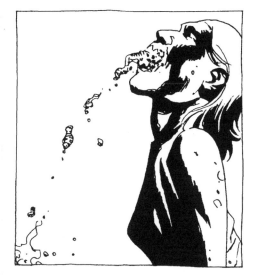

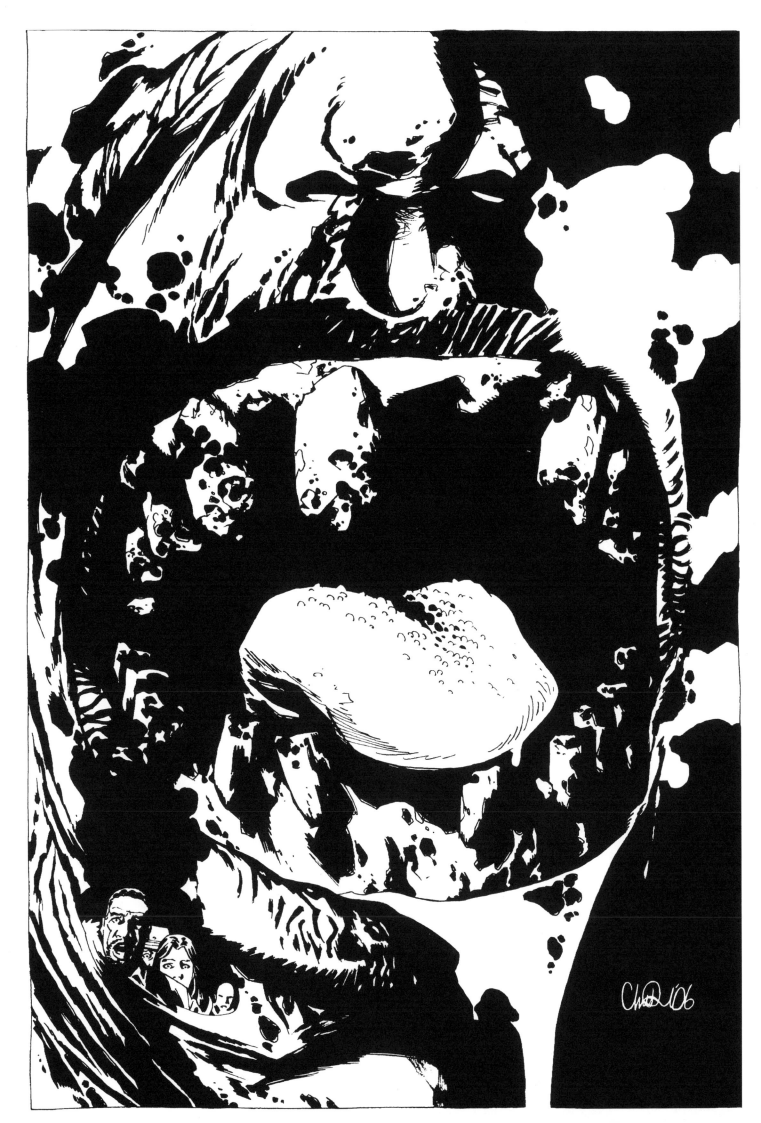

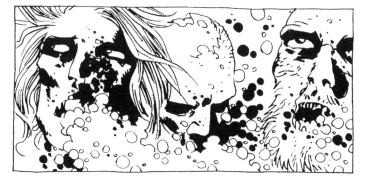

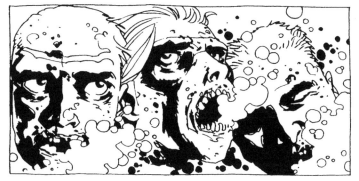

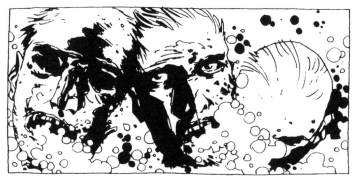

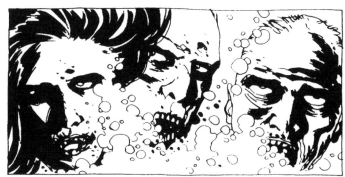

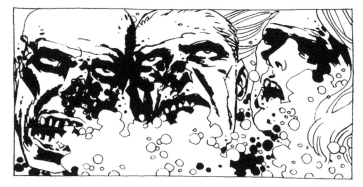

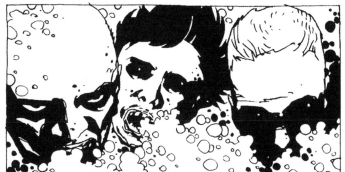

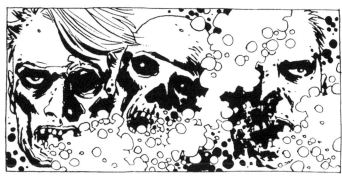

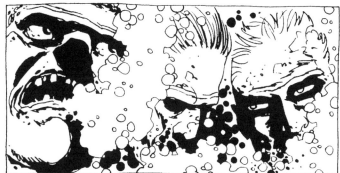

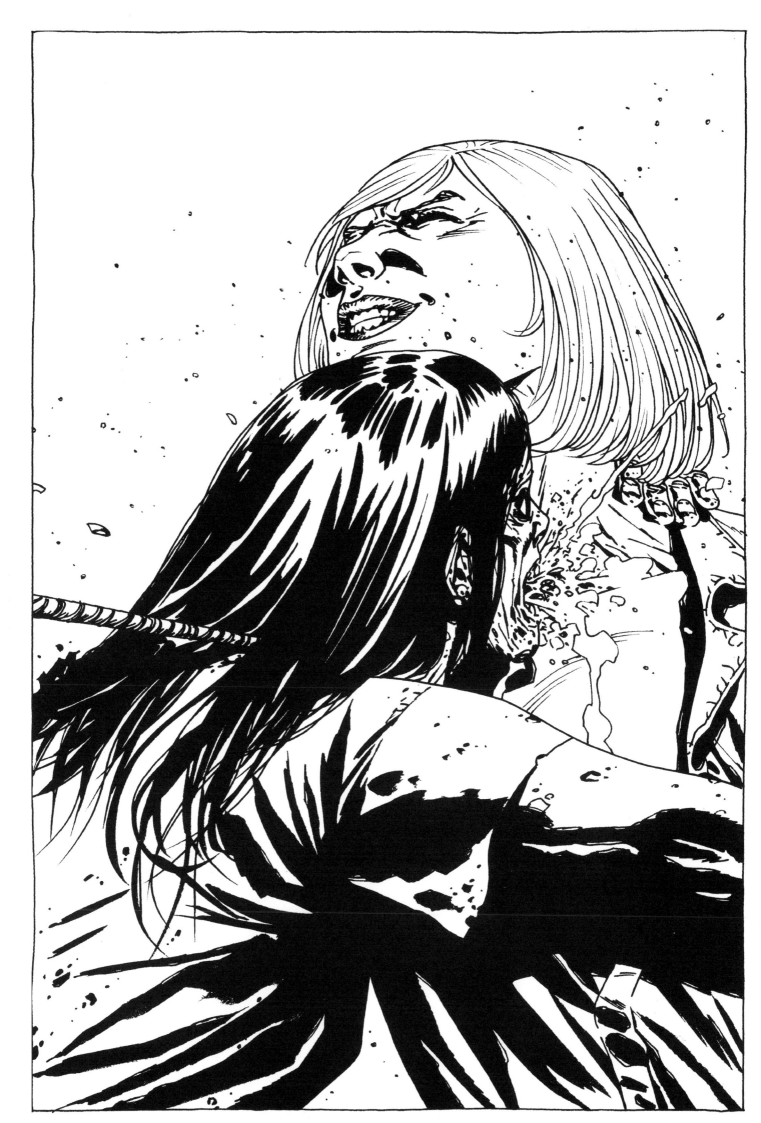

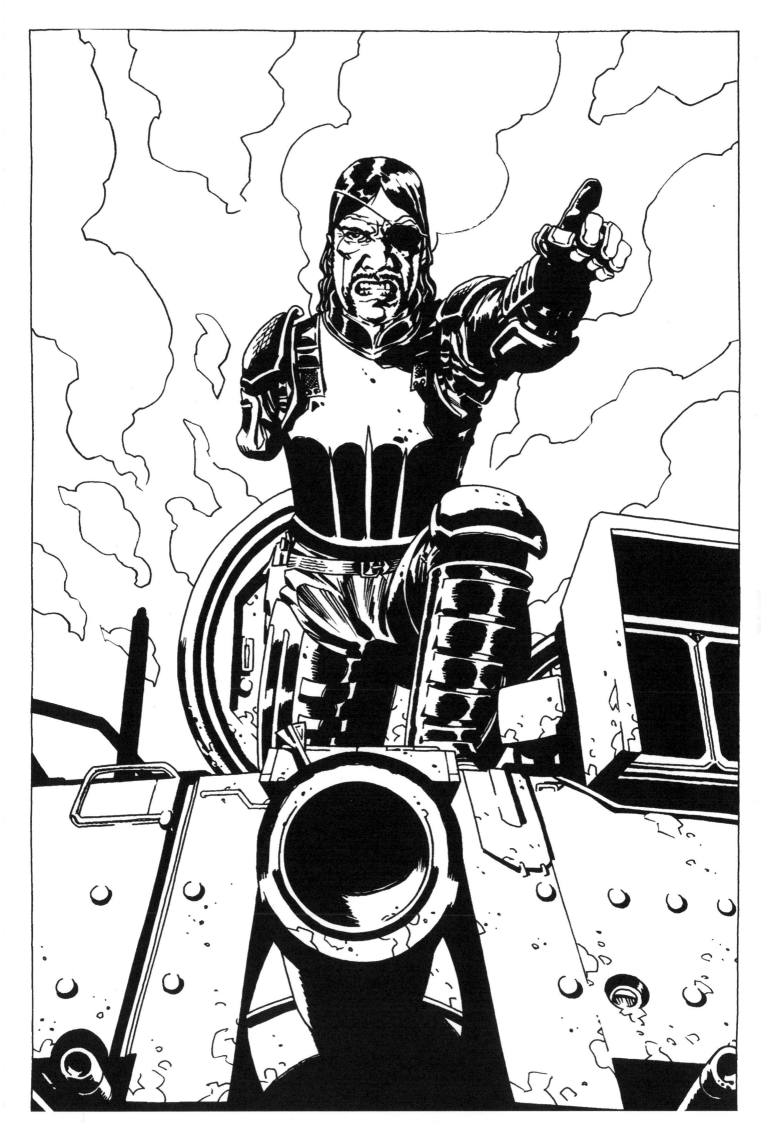

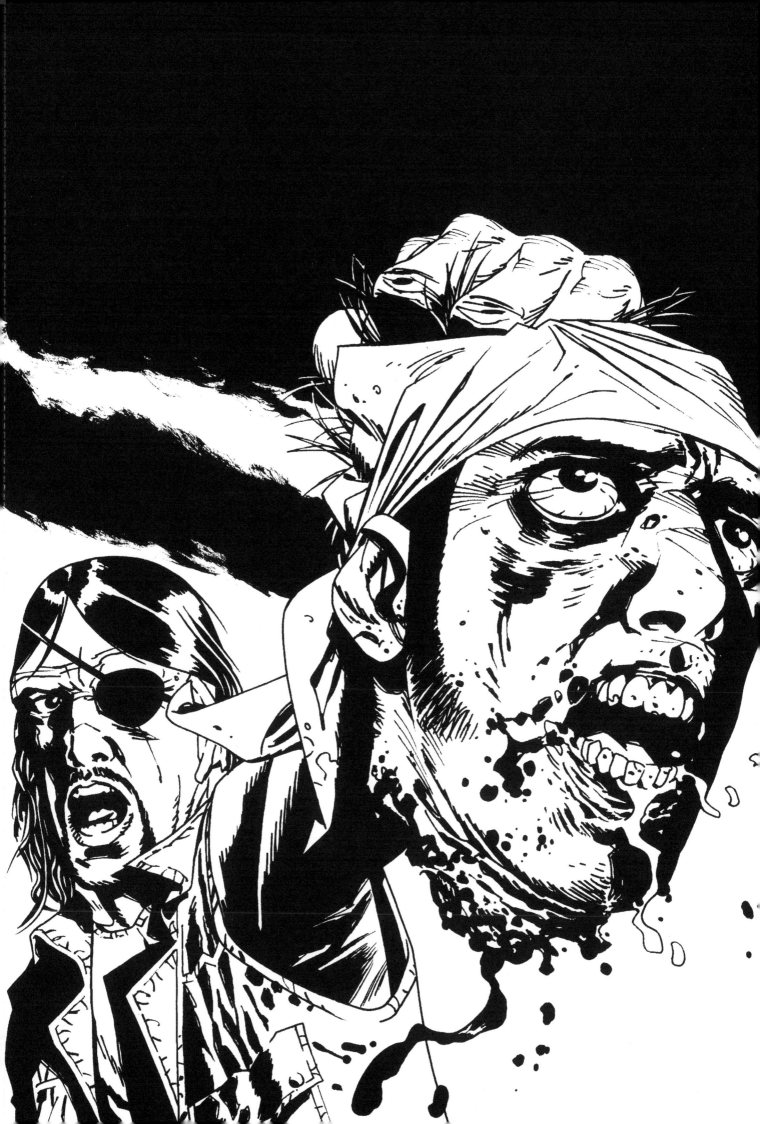

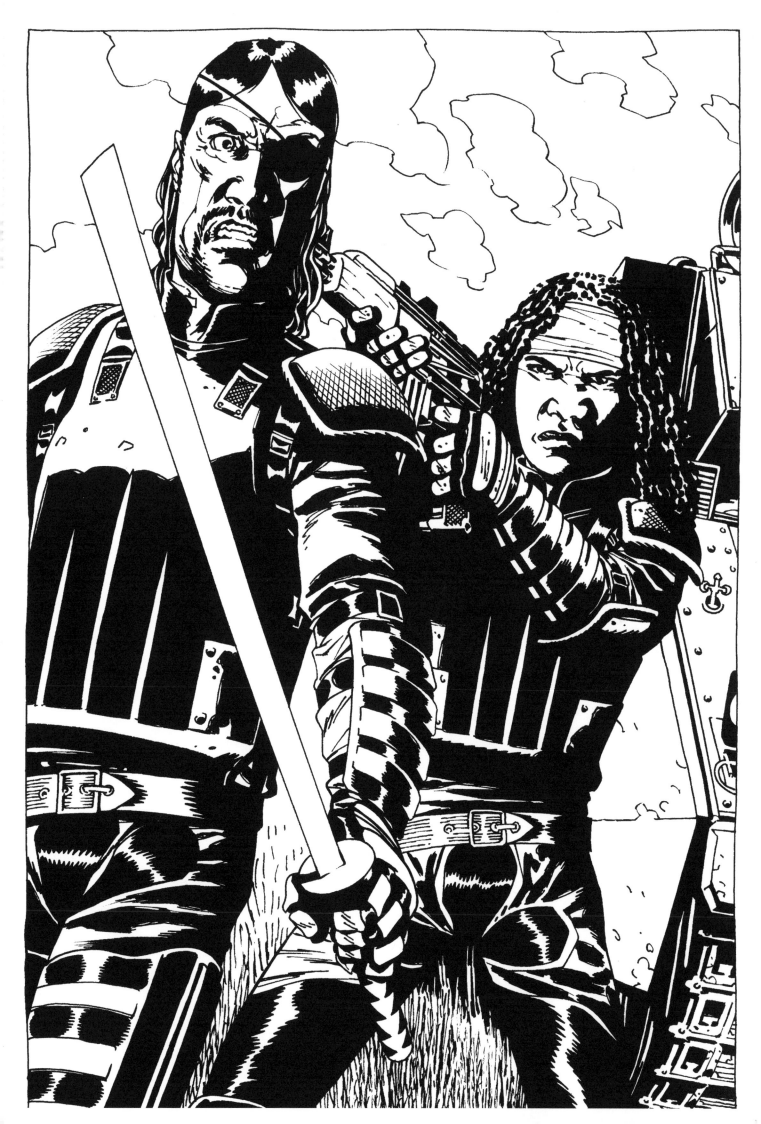

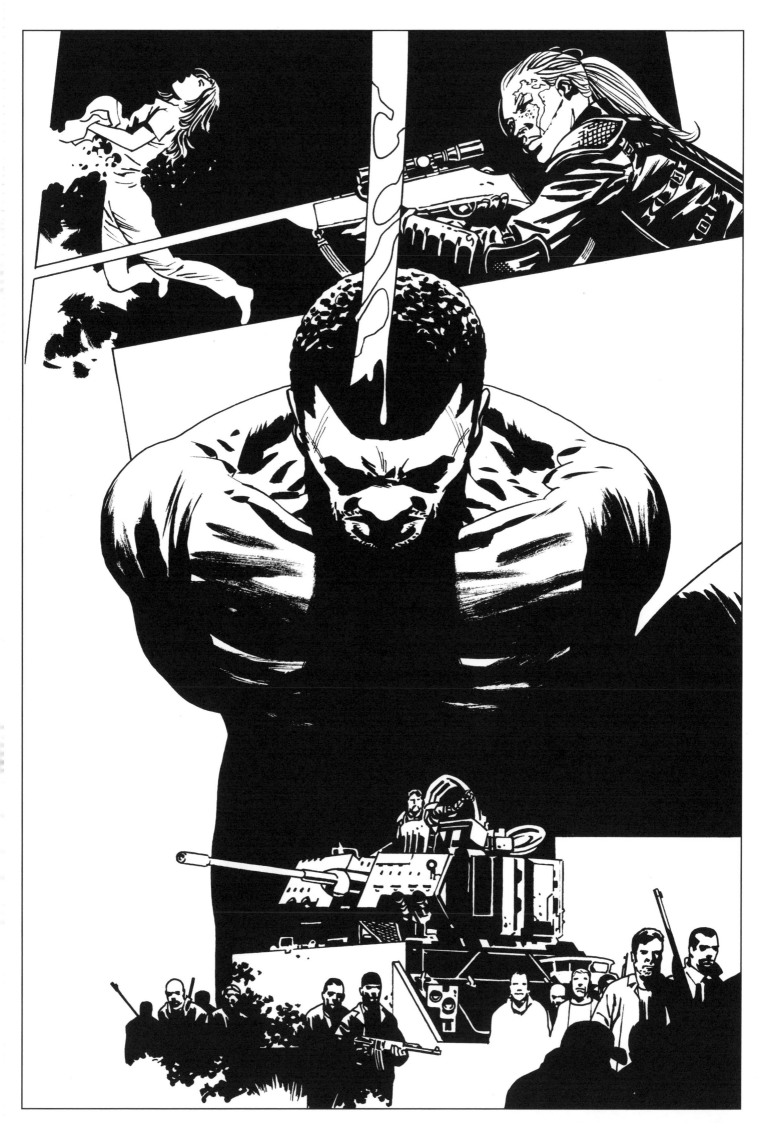

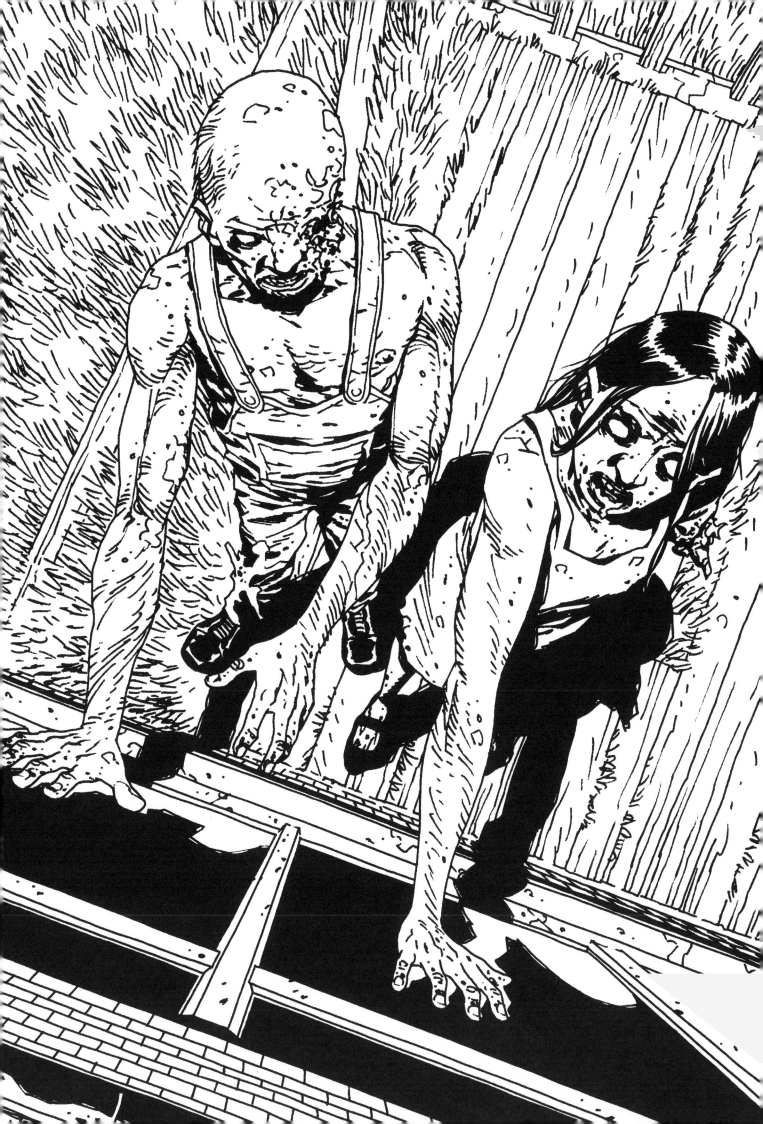

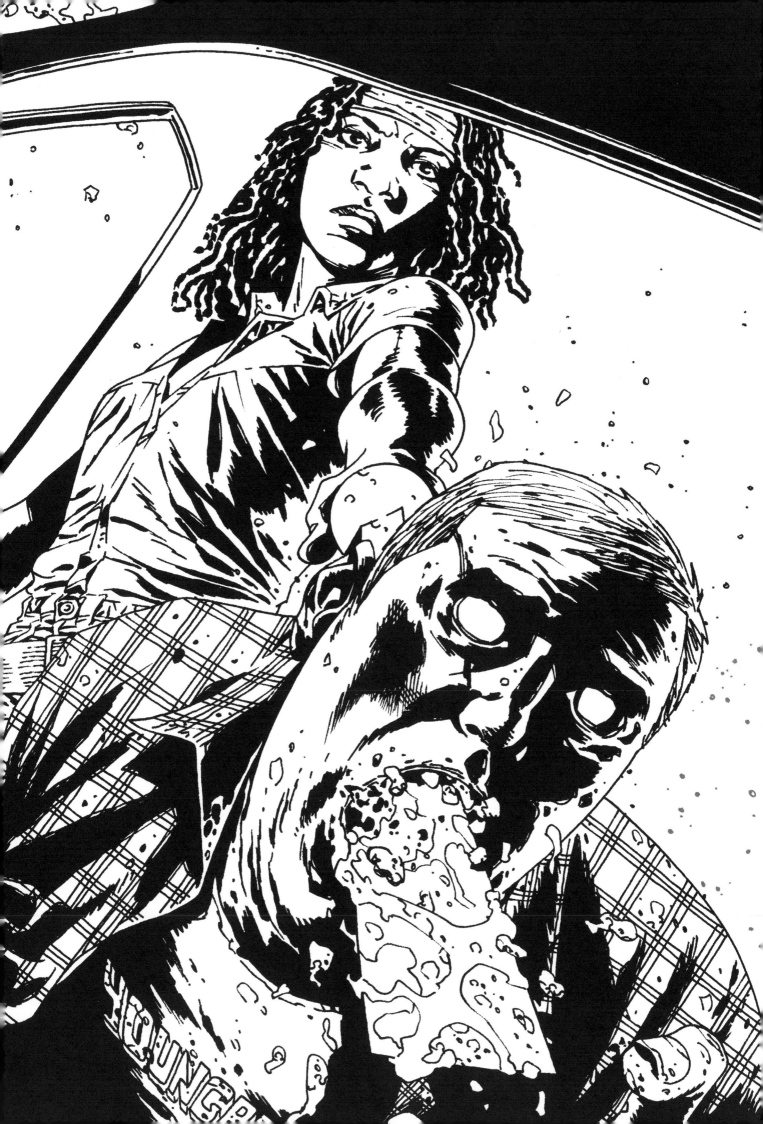

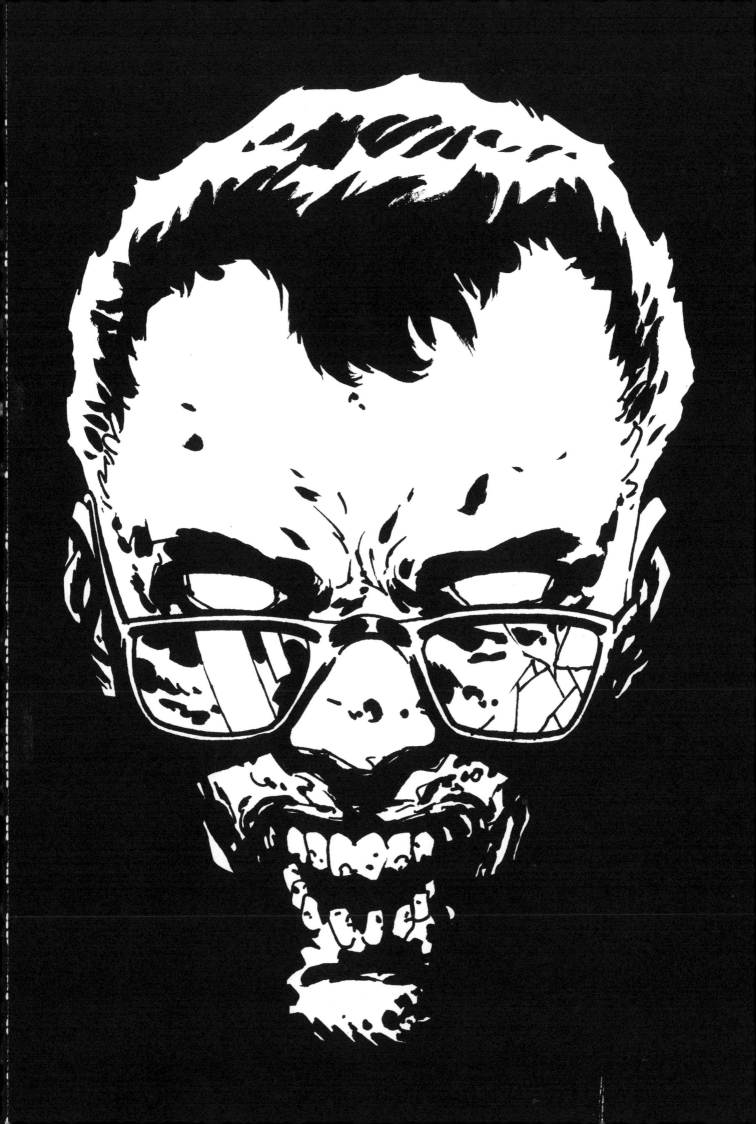

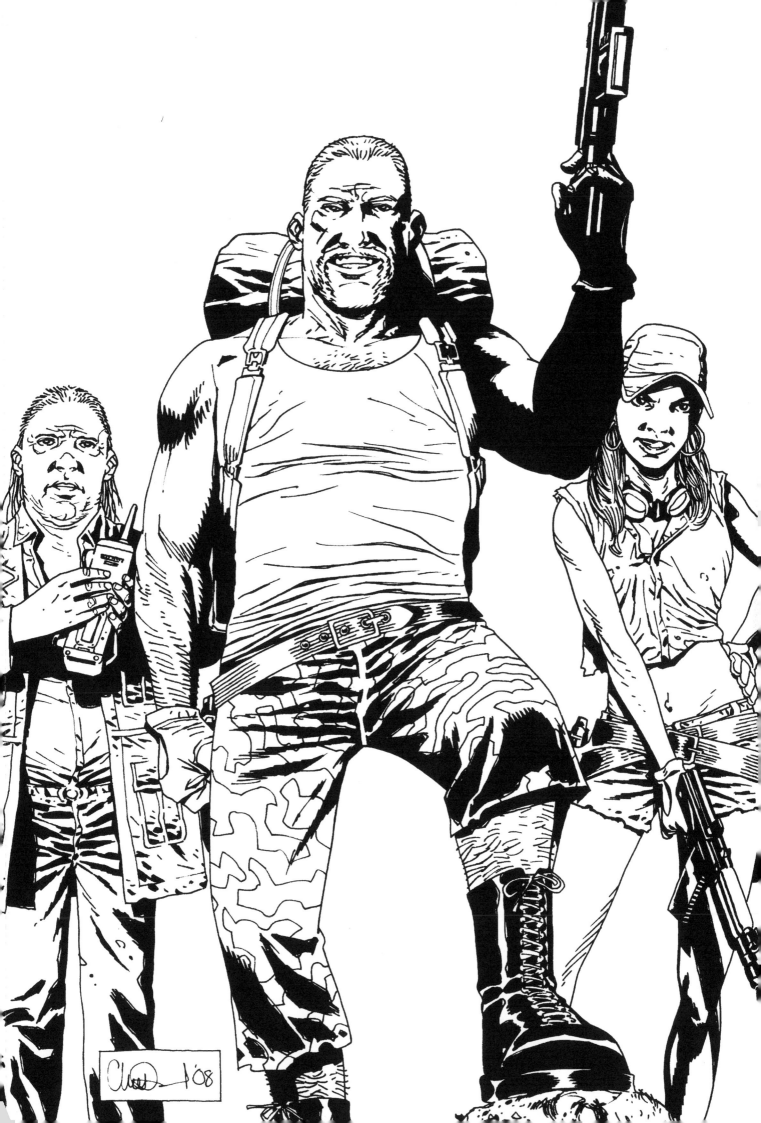

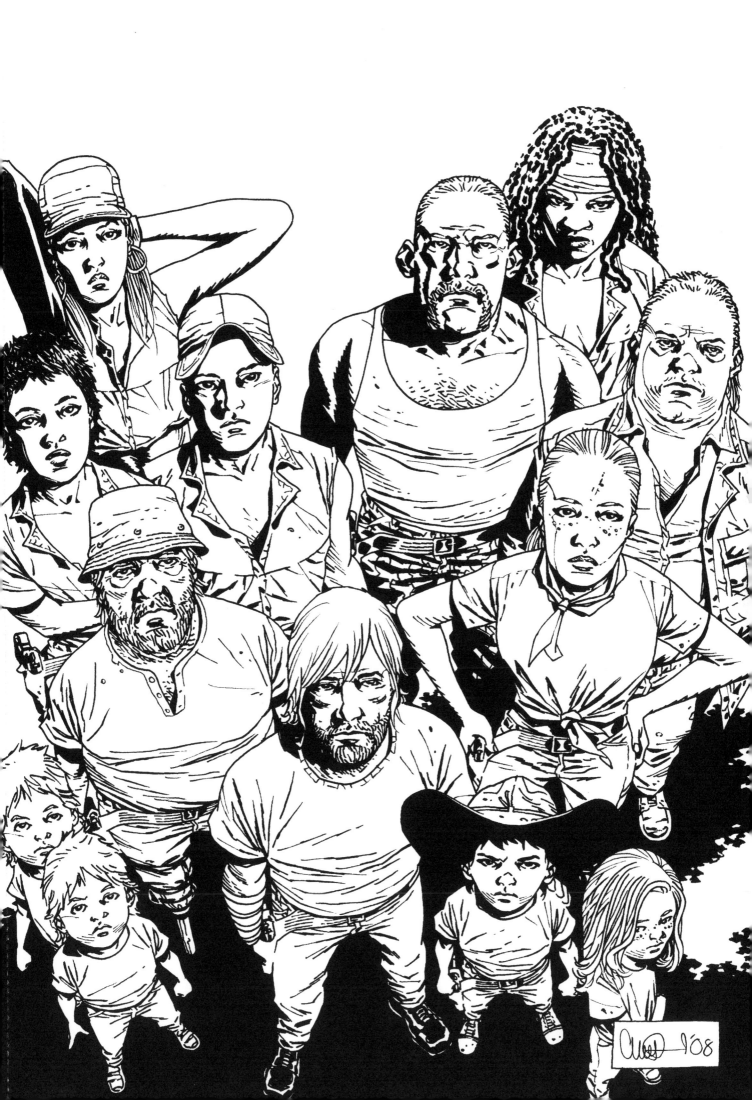

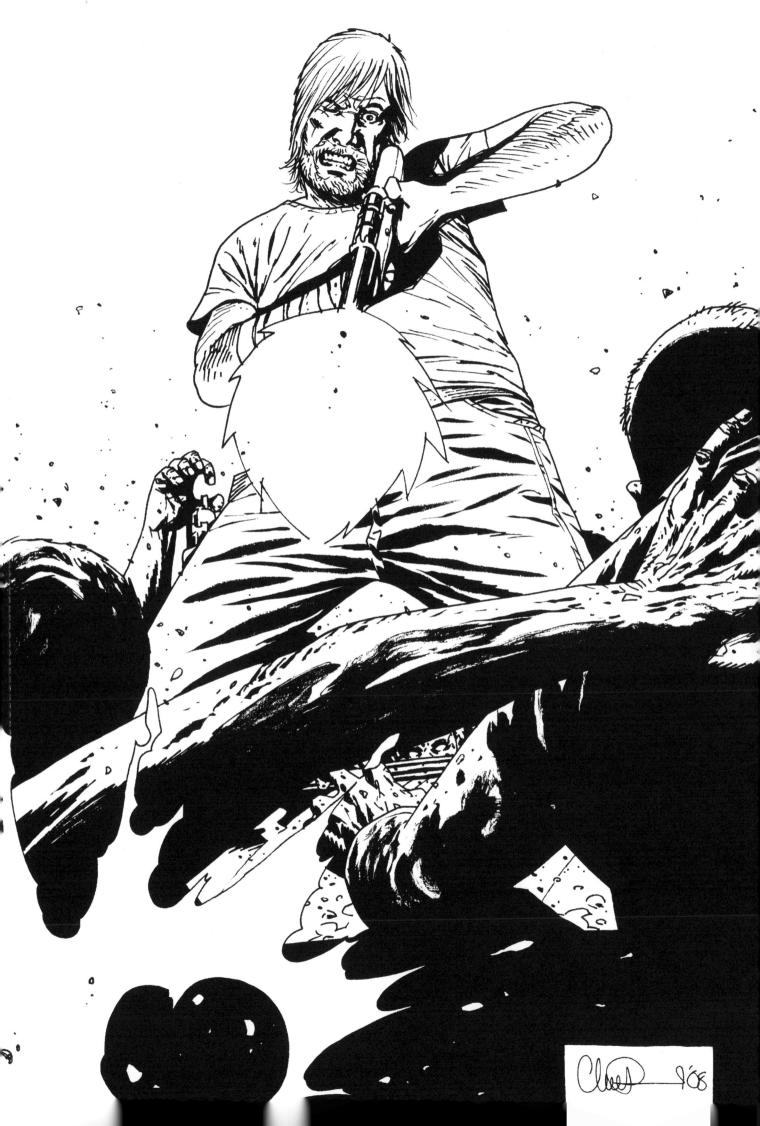

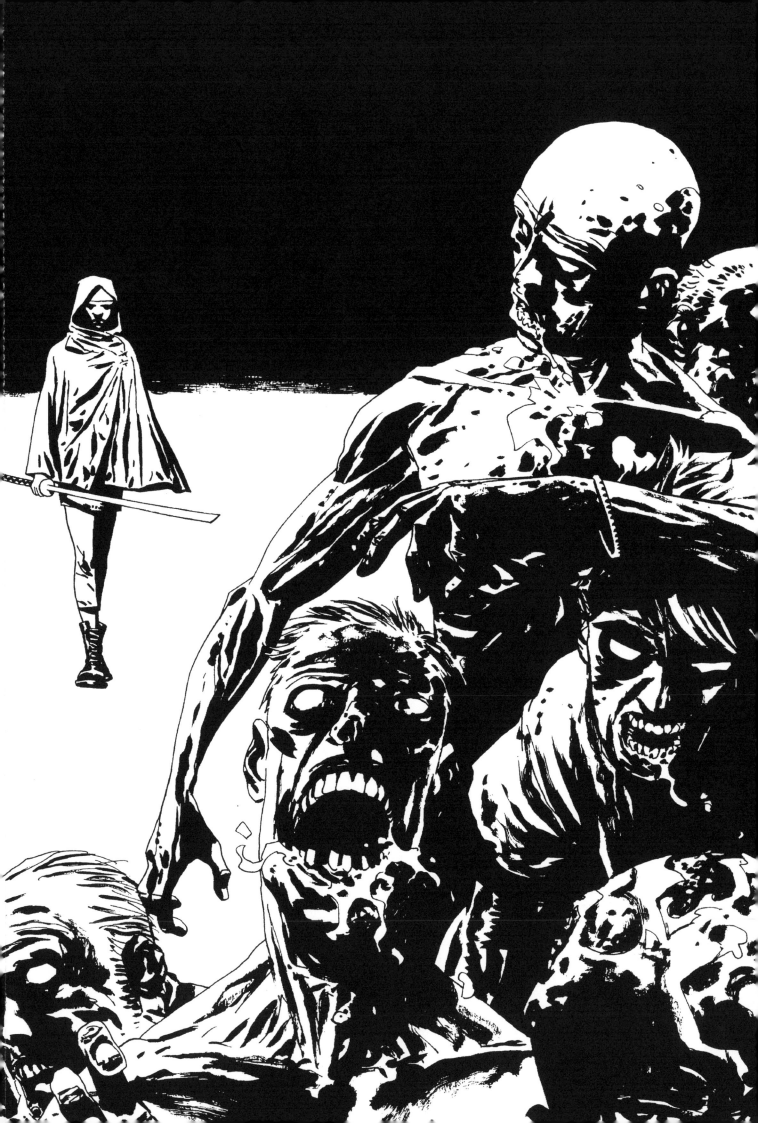

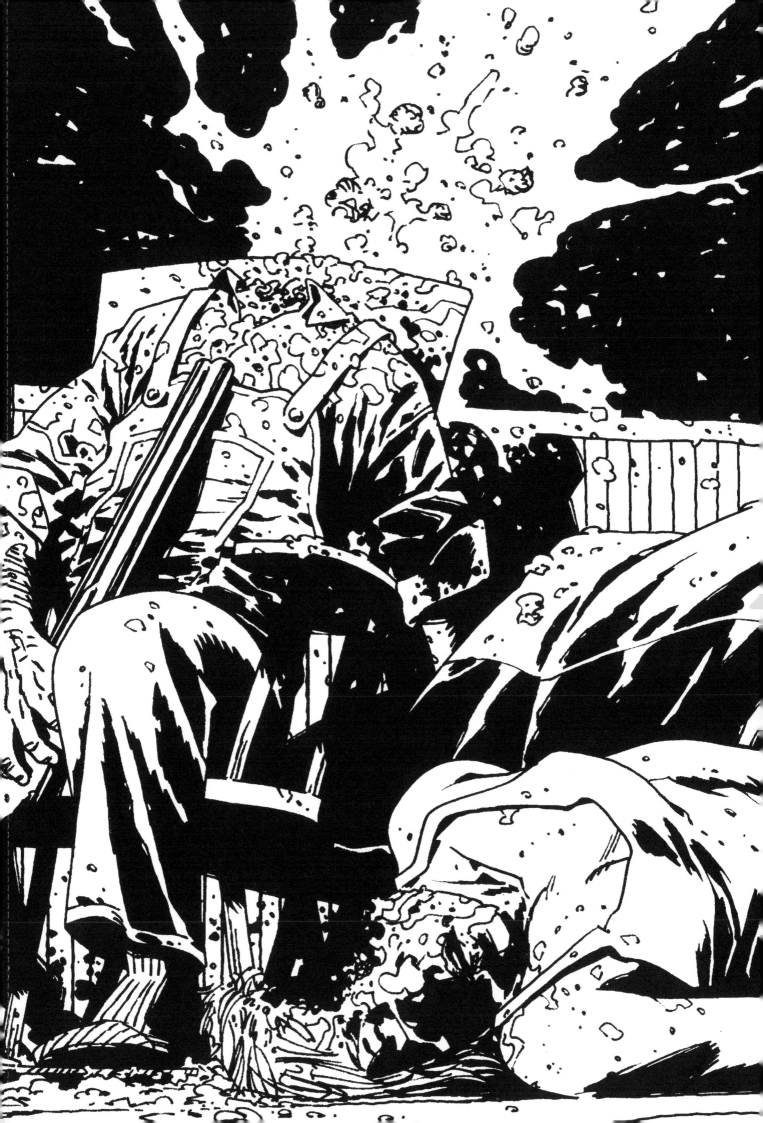

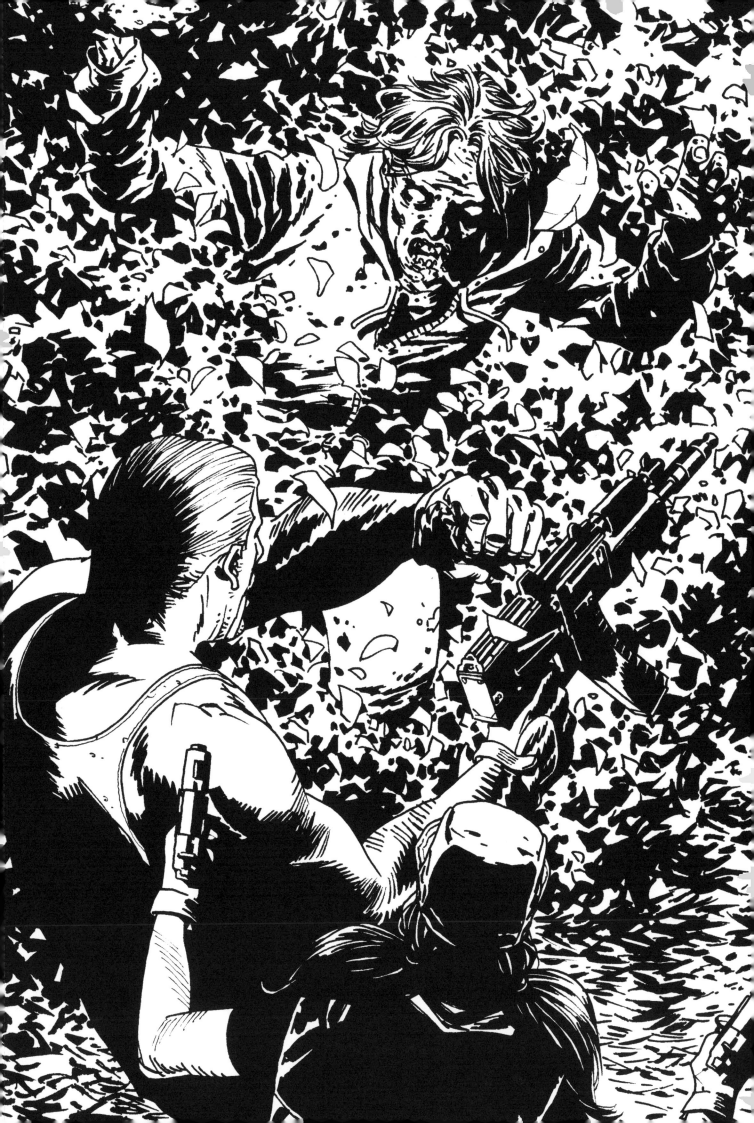

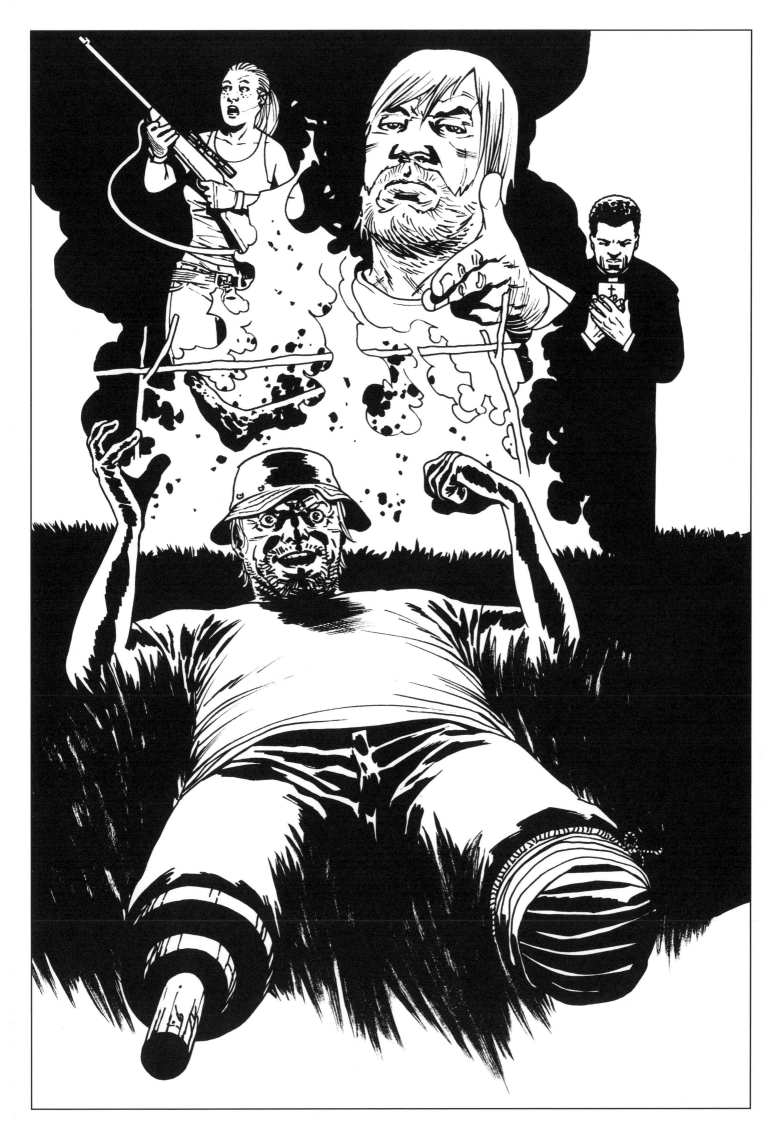

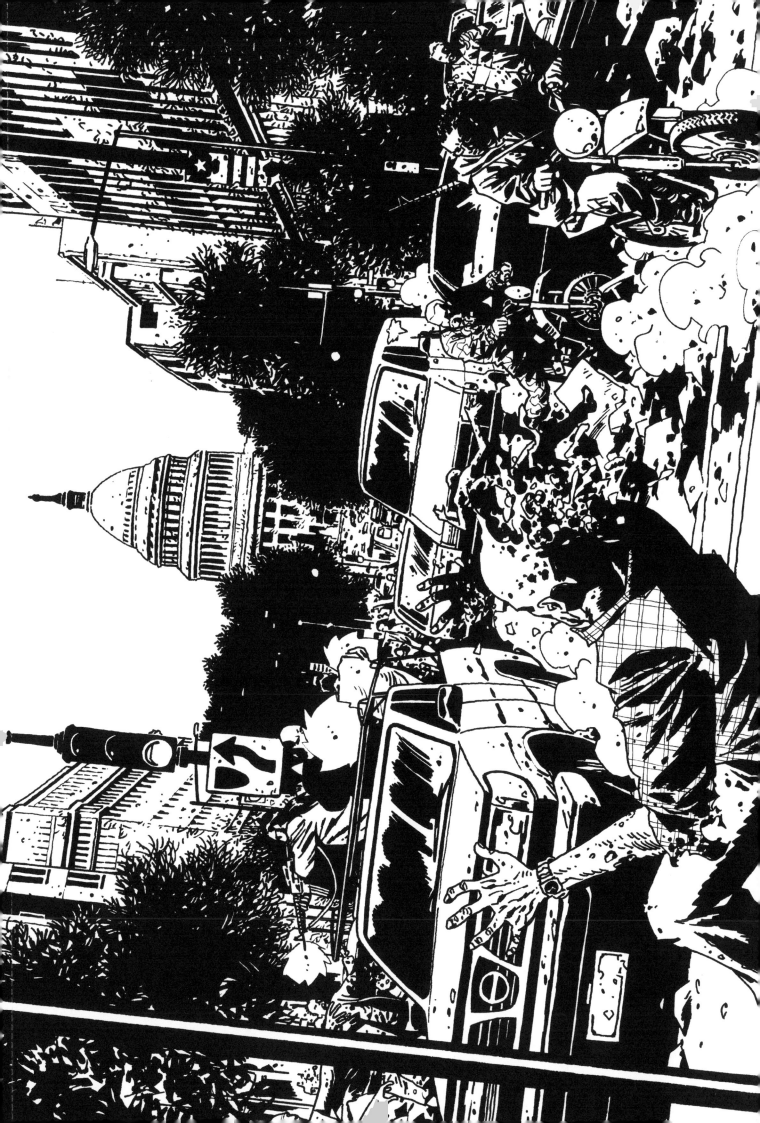

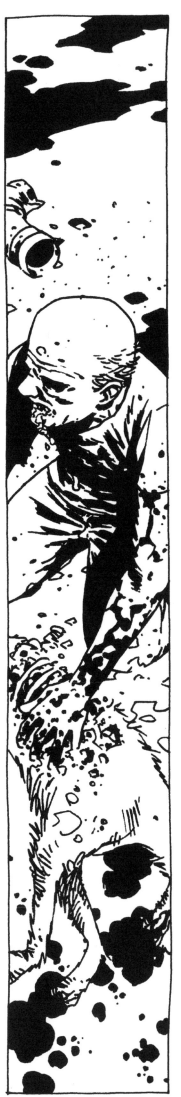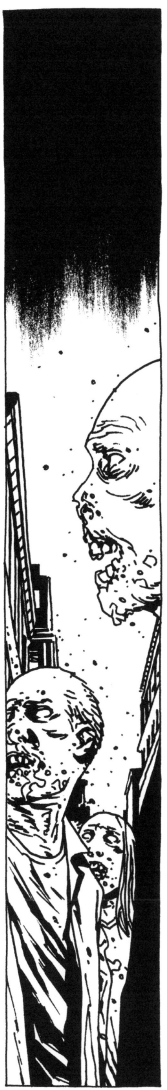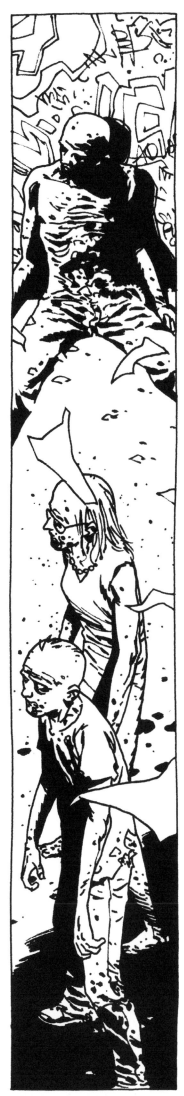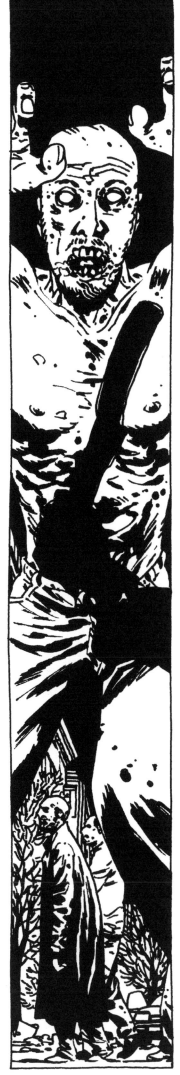

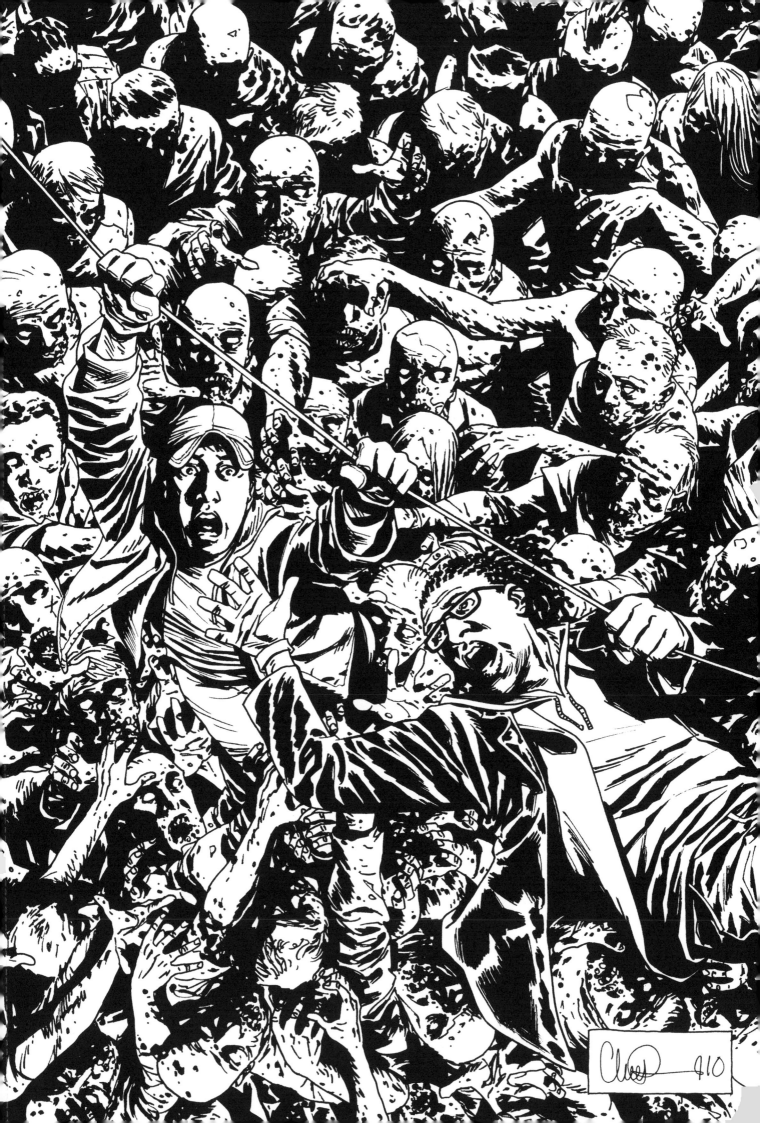

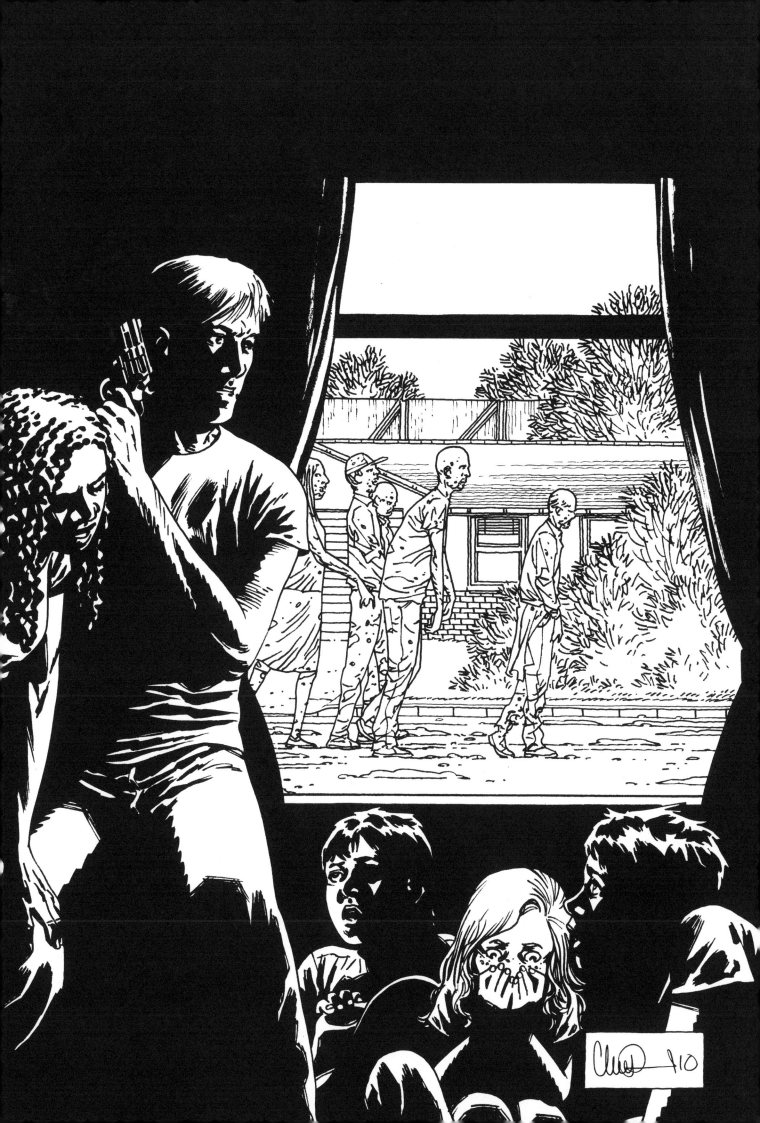

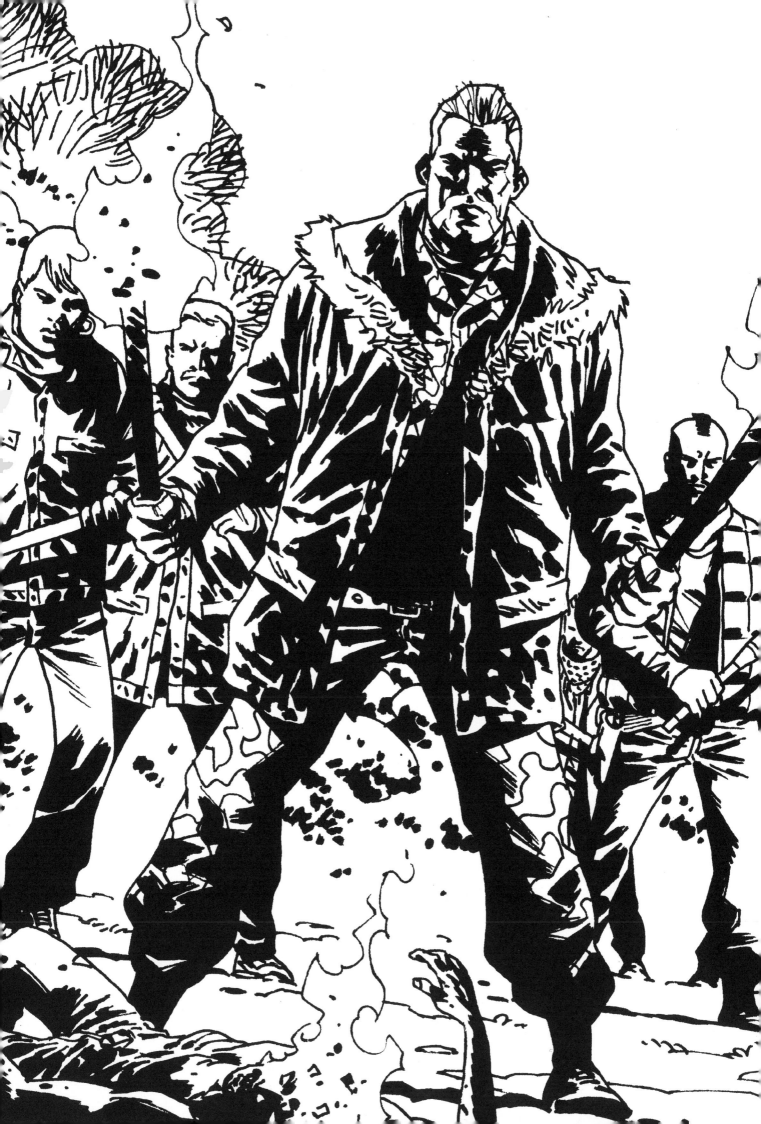

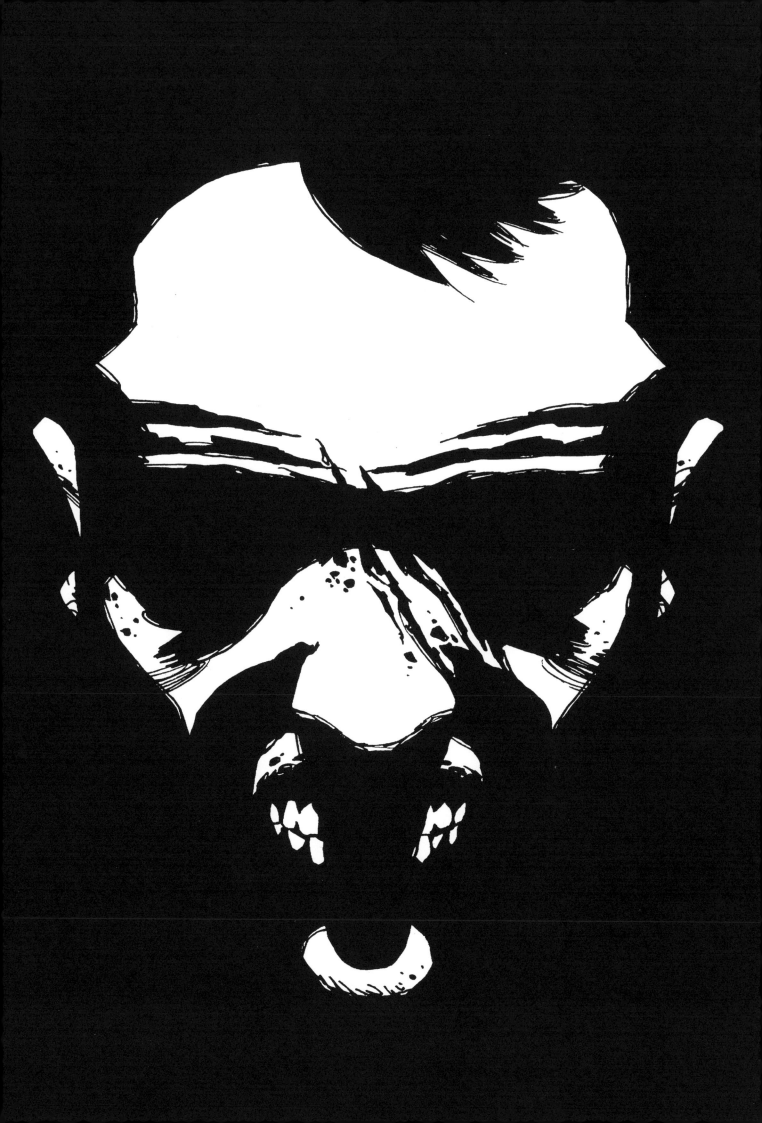

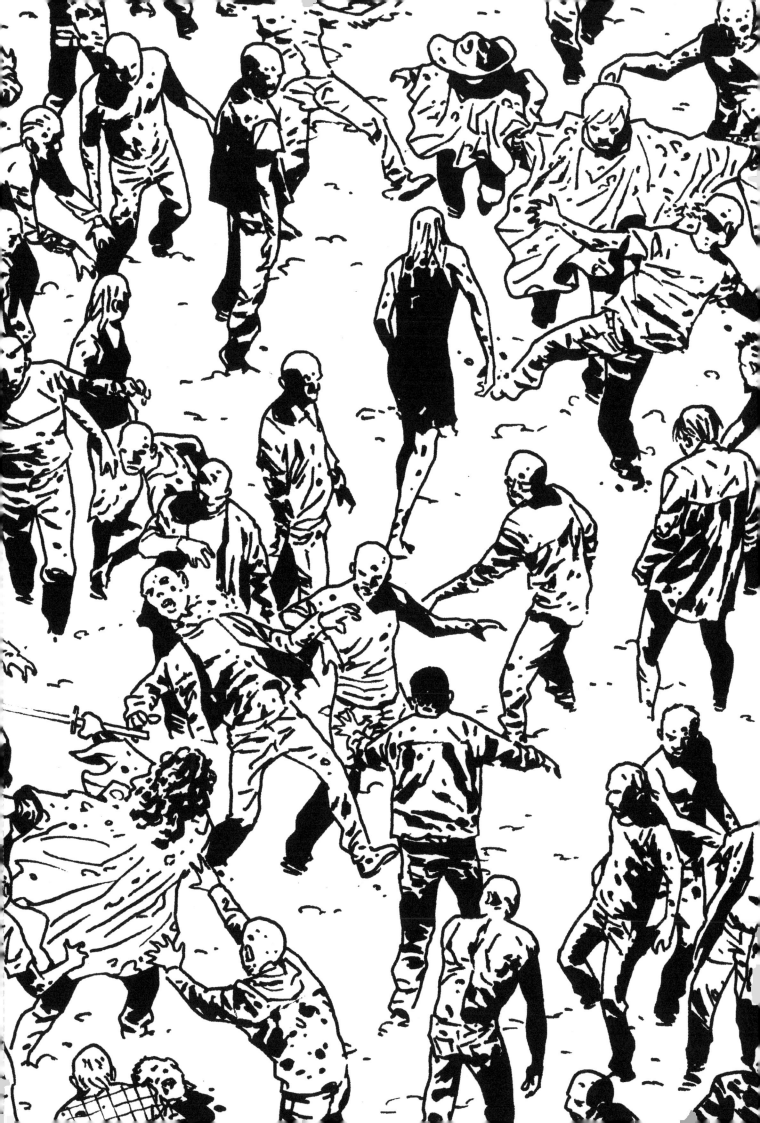

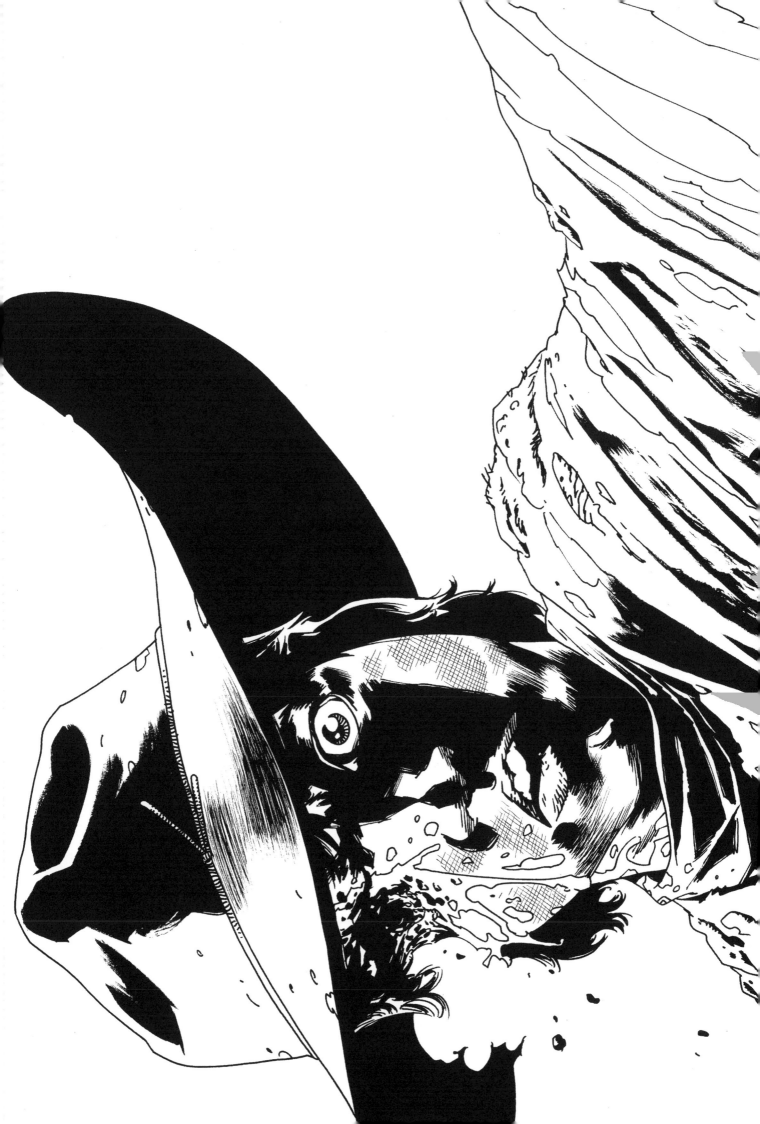

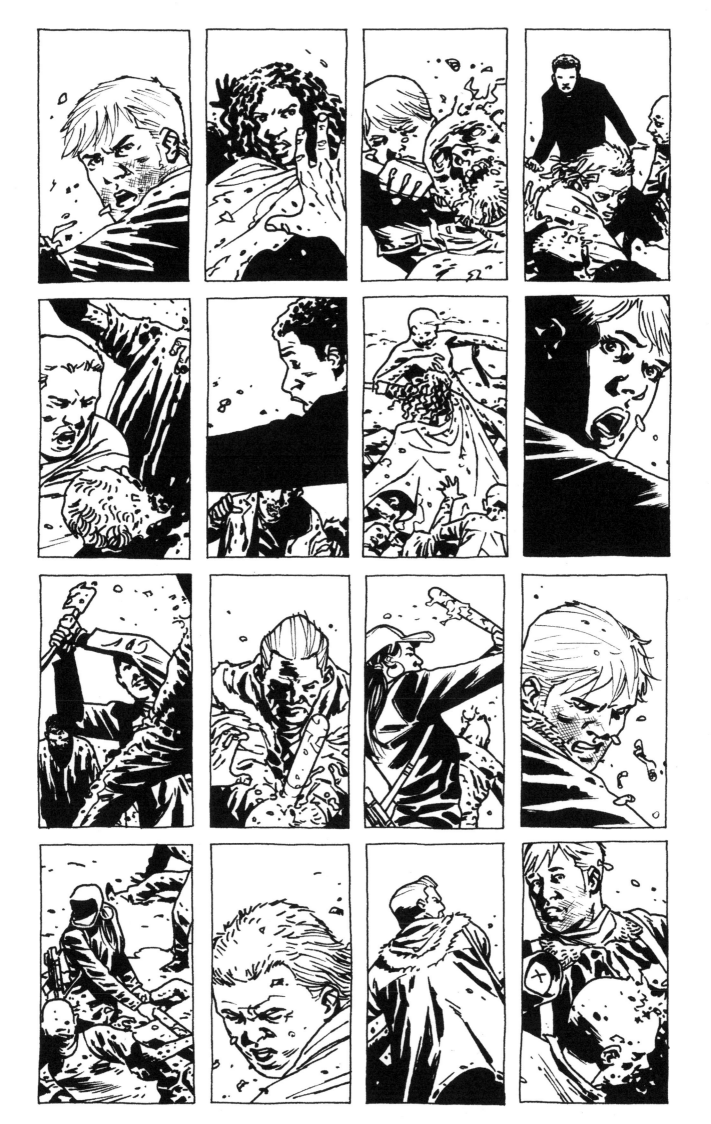

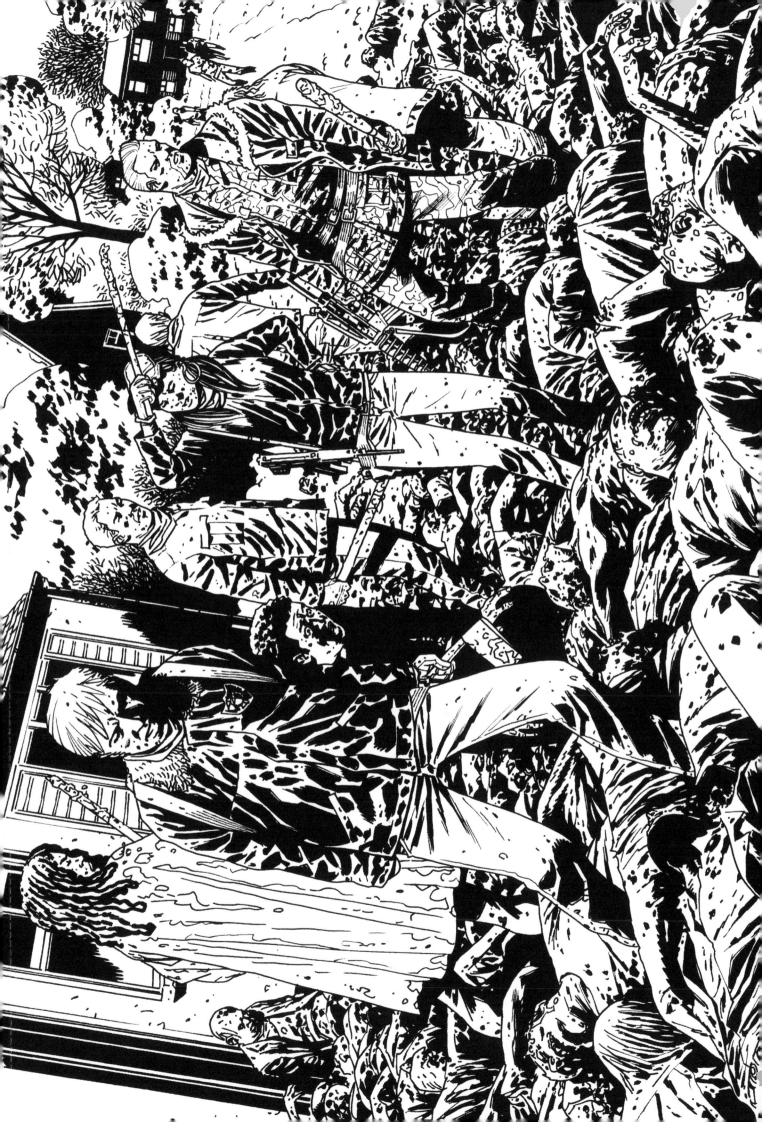

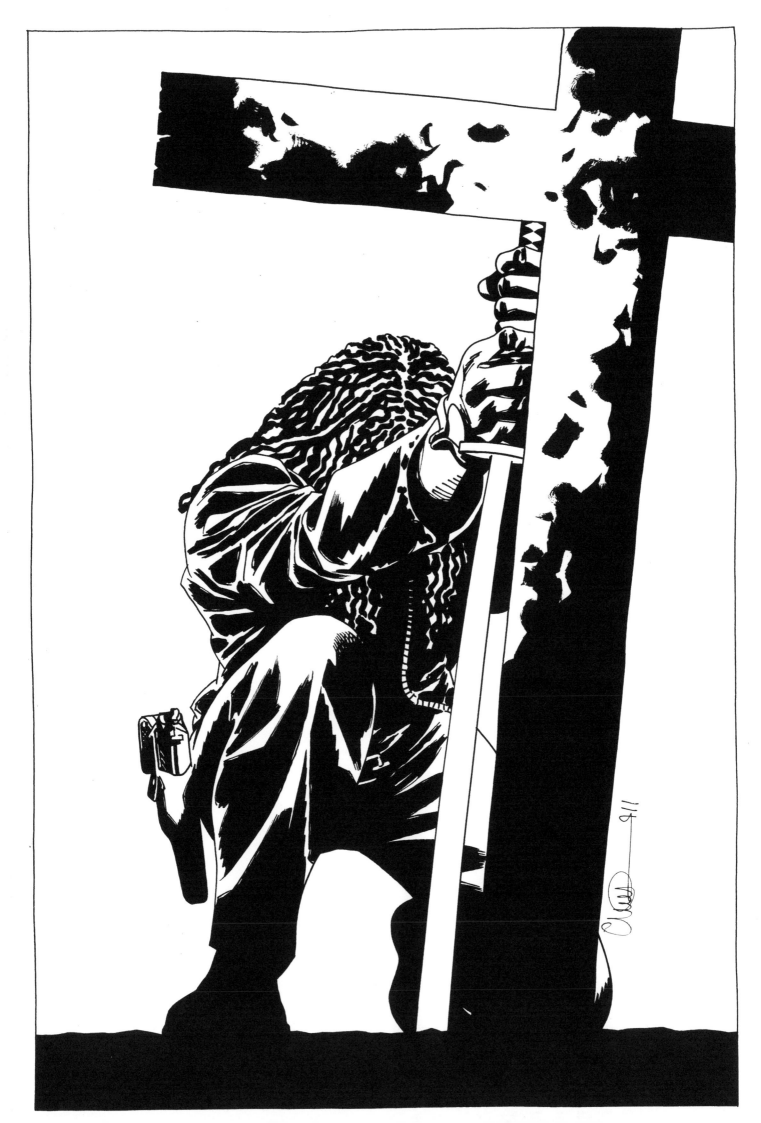

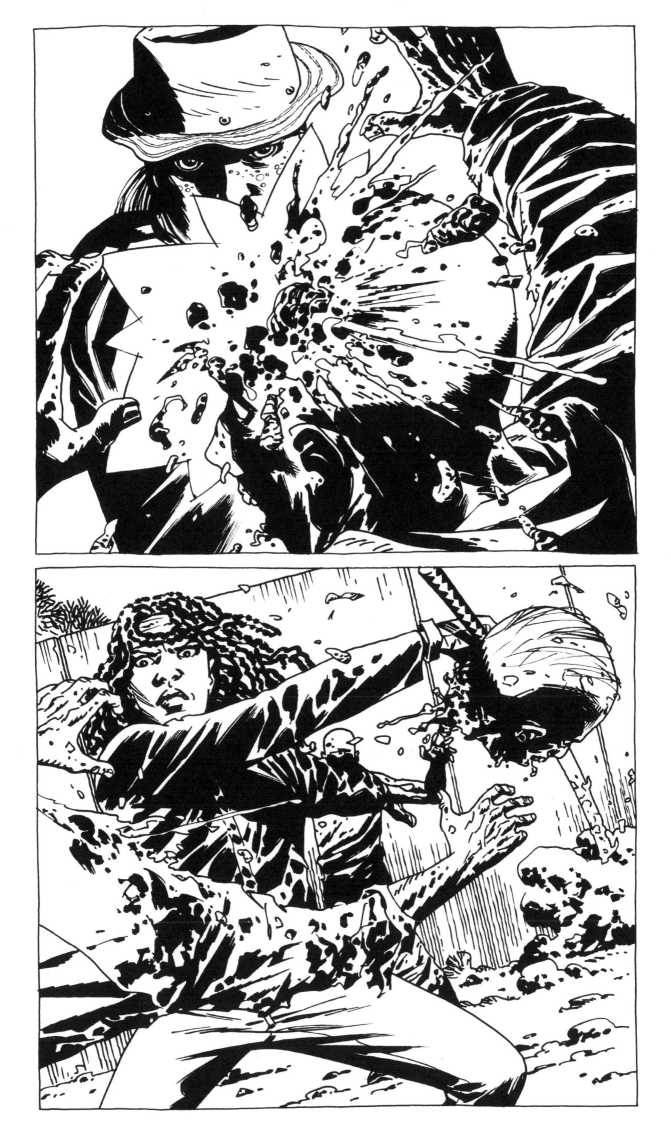

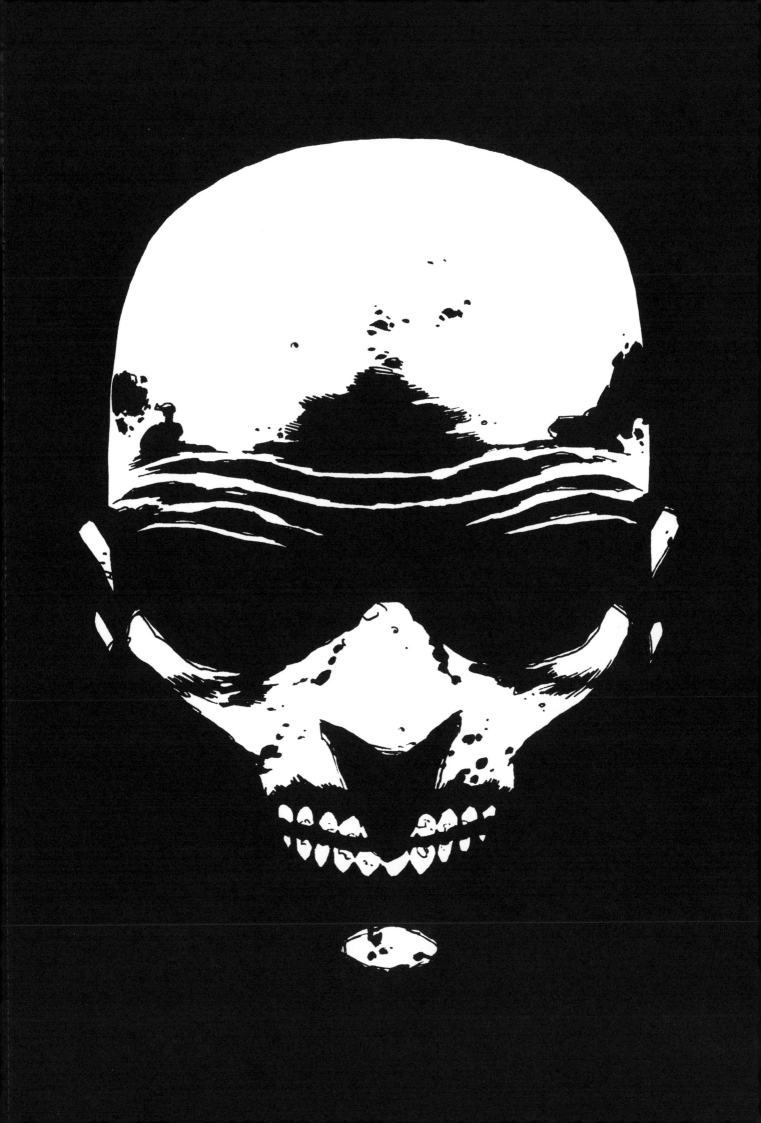

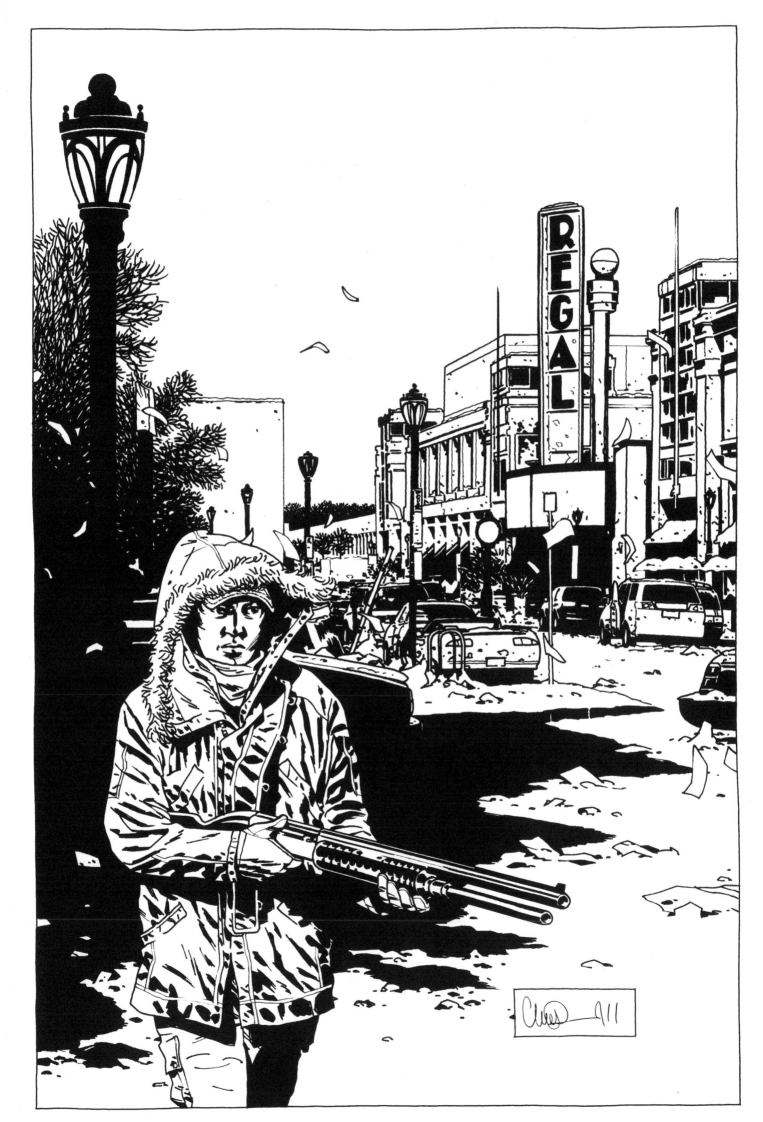

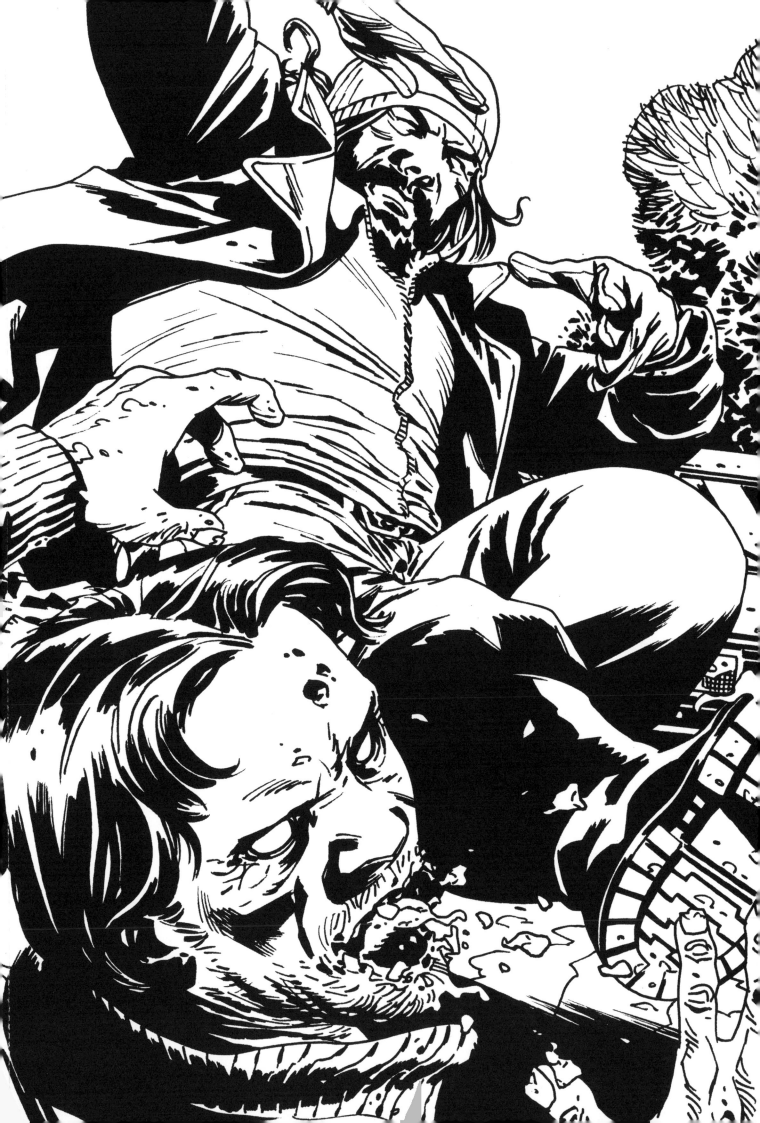

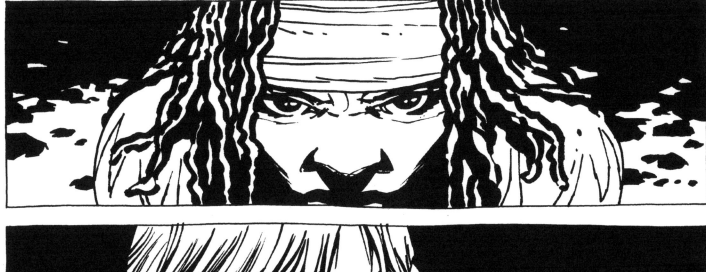

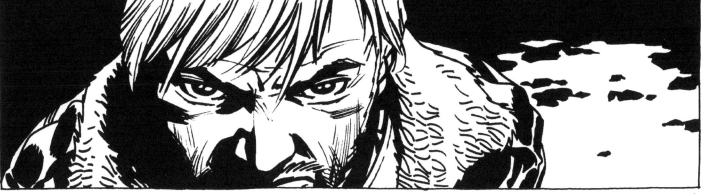

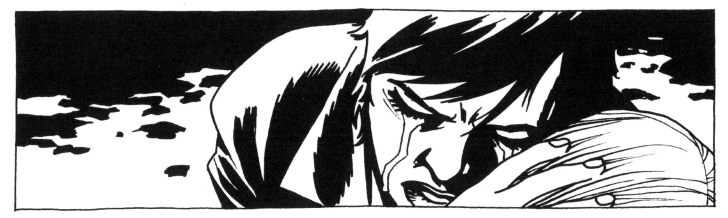

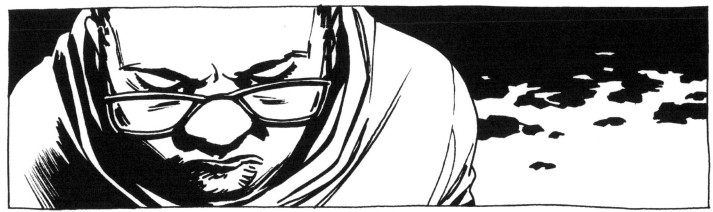

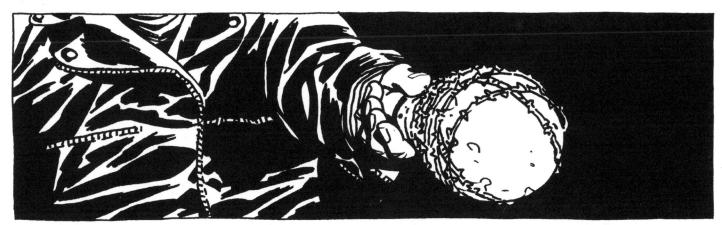

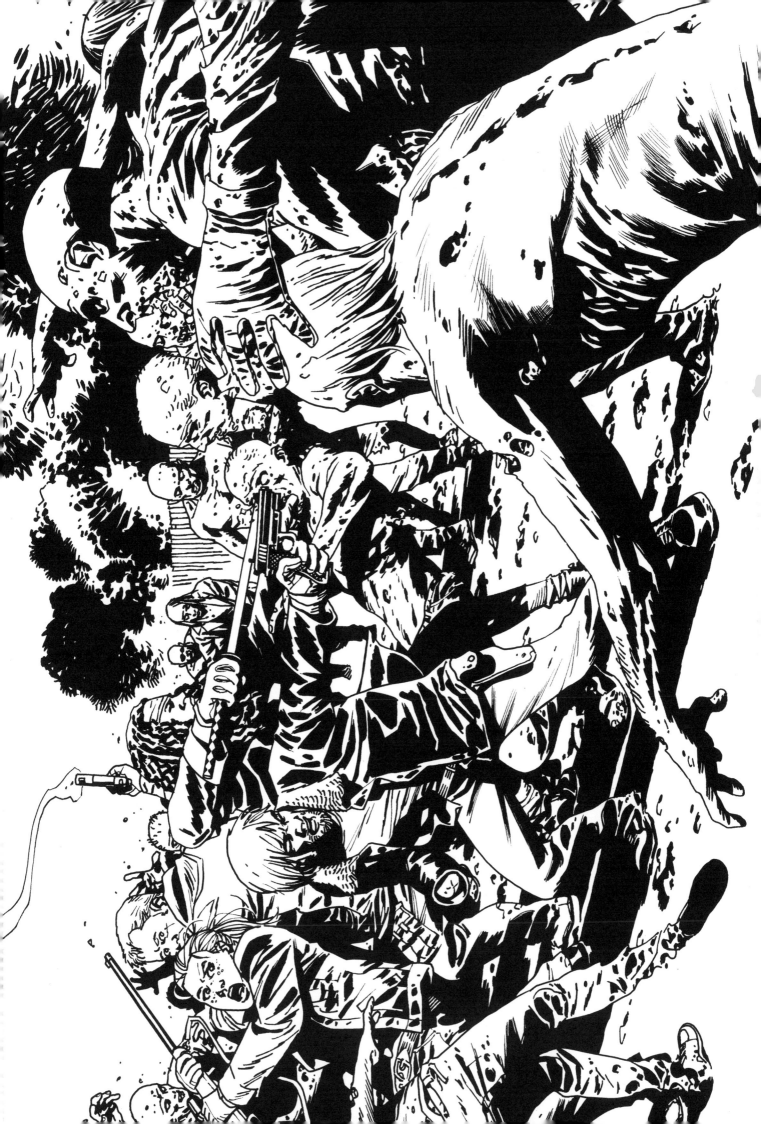

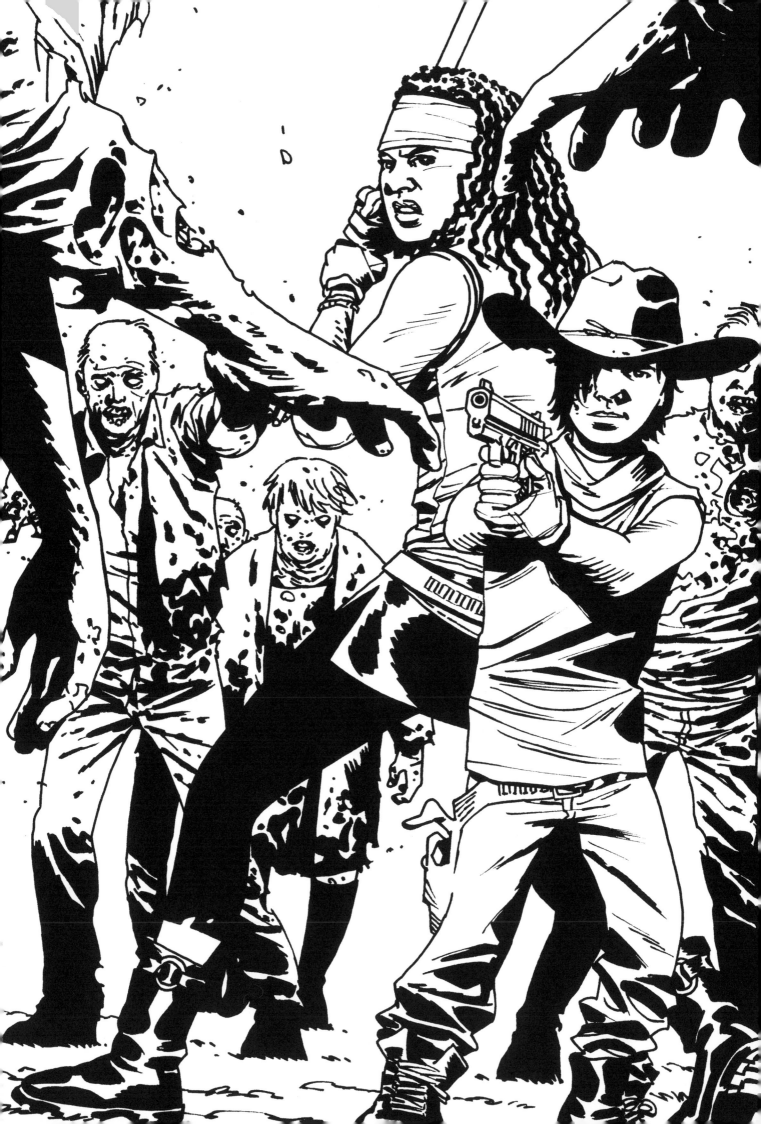

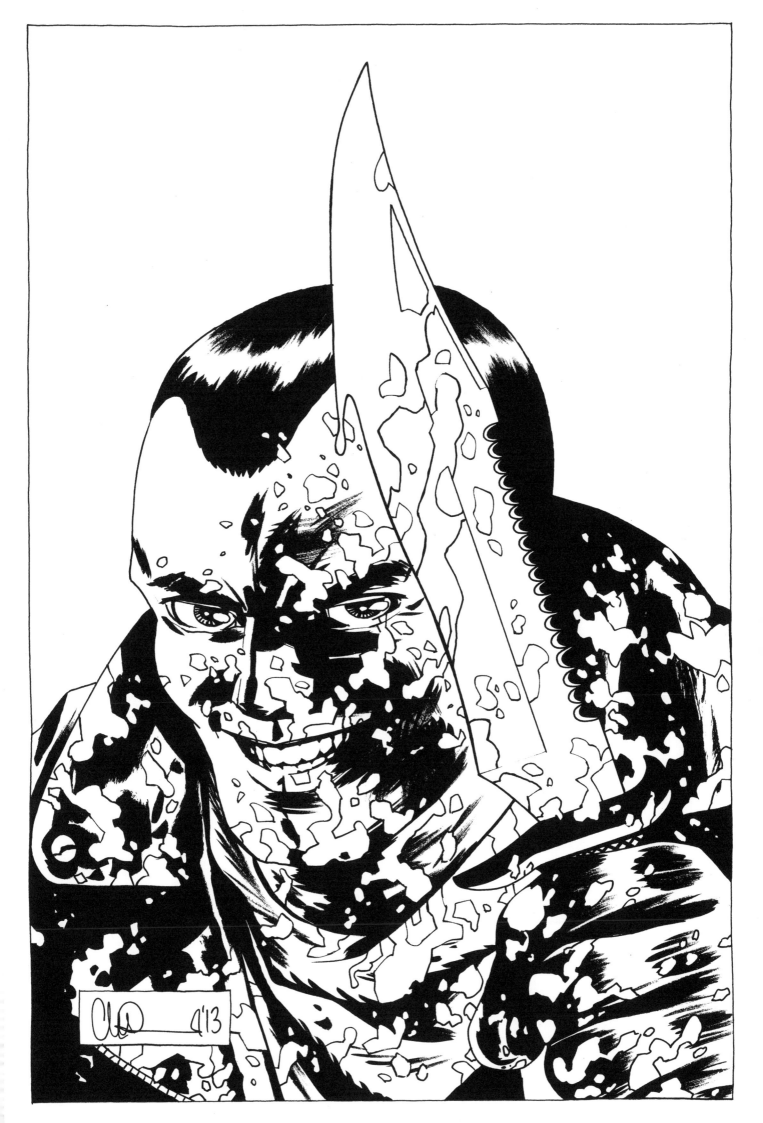

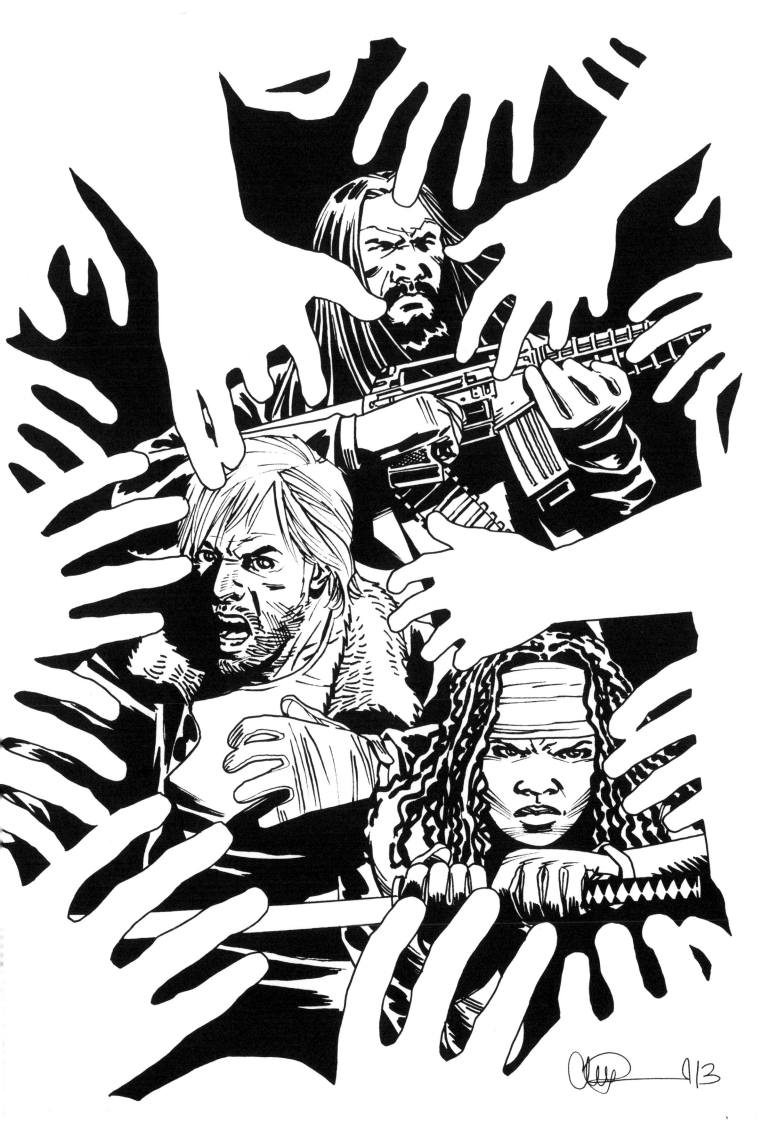

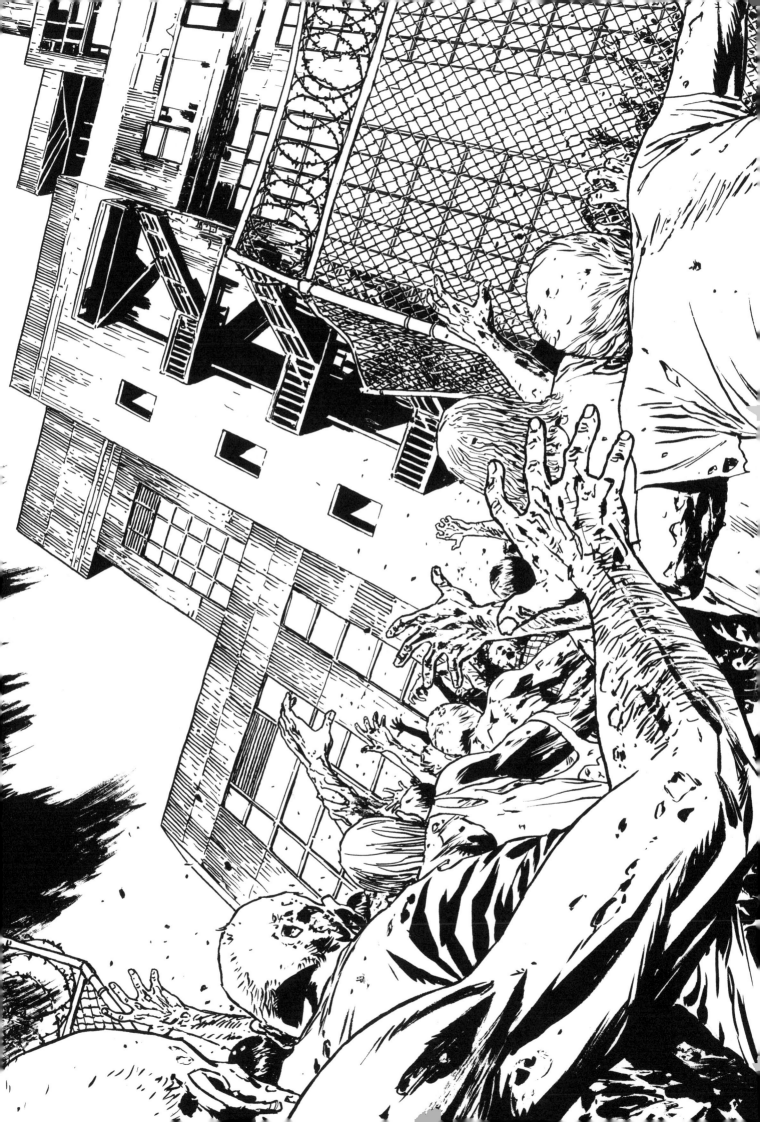